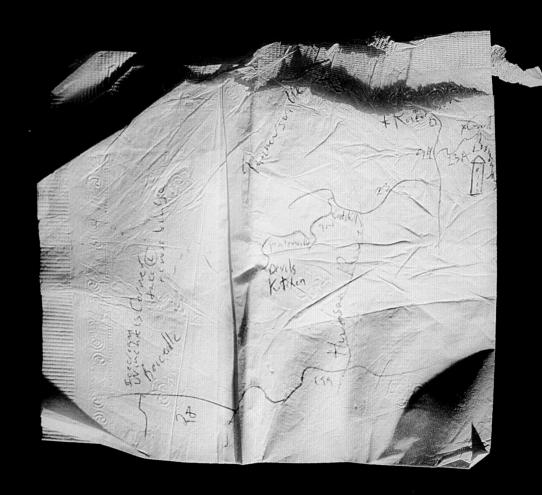

Haunted Houses

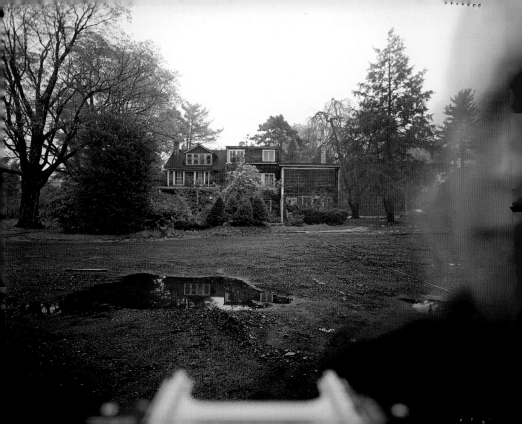

Haunted Houses

Corinne May Botz

The Monacelli Press

Published in the United States by The Monacelli Press,
a division of Random House, Inc., New York.

The Monacelli Press and the M design
are registered trademarks of Random House, Inc.

Library of Congress Cataloging-in-Publication Data:
Botz, Corinne May.
Haunted houses / Corinne May Botz.
p. cm.
Includes bibliographical references.
ISBN 978-1-58093-291-2
1. Architectural photography. 2. Photography of interiors.
3. Haunted houses—Pictorial works. 4. Spirit photography.
I. Title.
TR659.B67 2010
133.122—dc22
2010010467

Designed by Michael Worthington, Counterspace, Los Angeles

Project editor: Karen Lehrman Bloch, Grafia Books, New York

Printed in China

www.monacellipress.com

10 9 8 7 6 5 4 3 2 1
First Edition

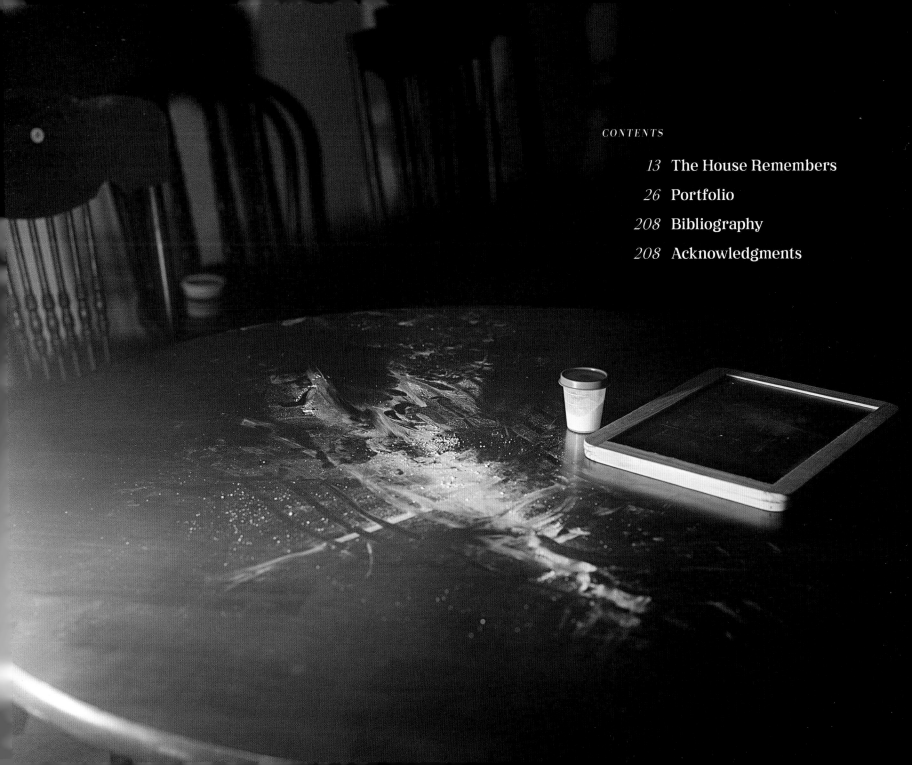

CONTENTS

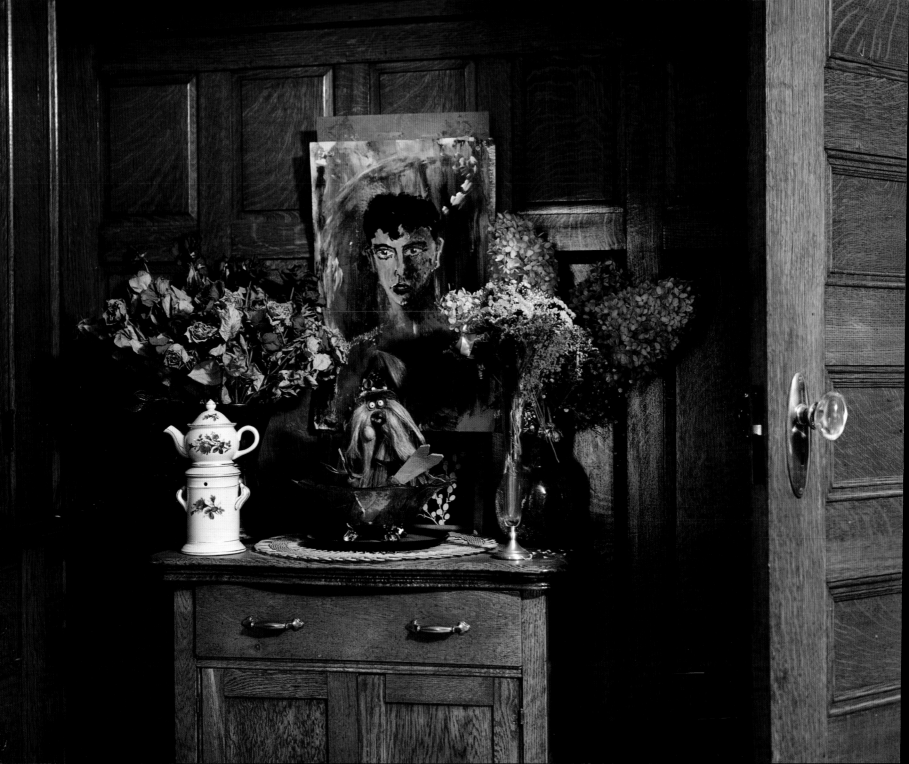

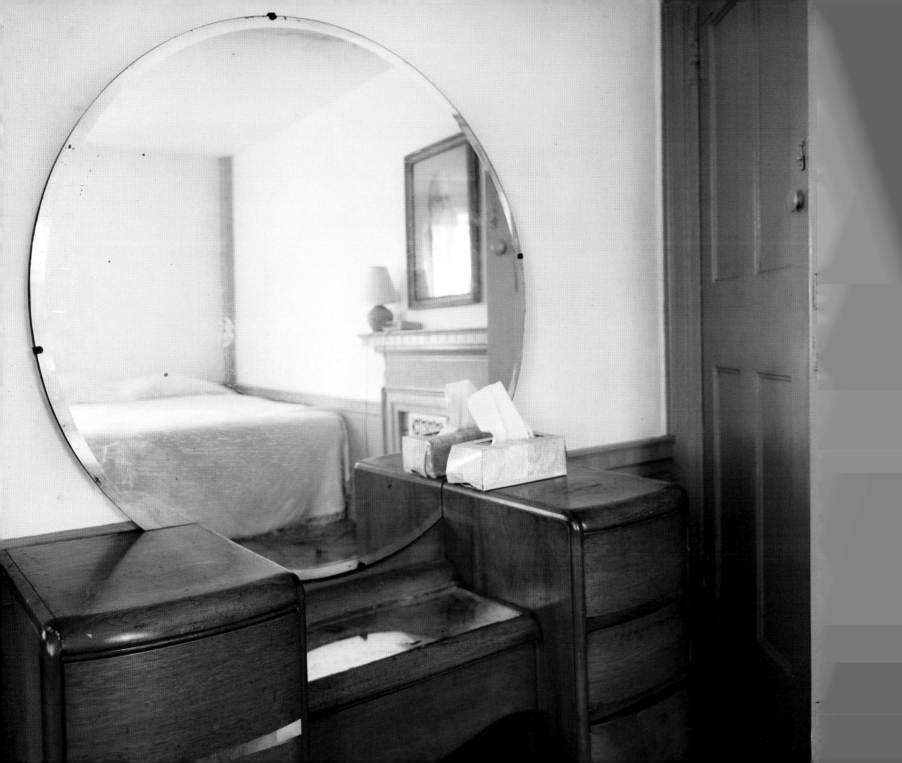

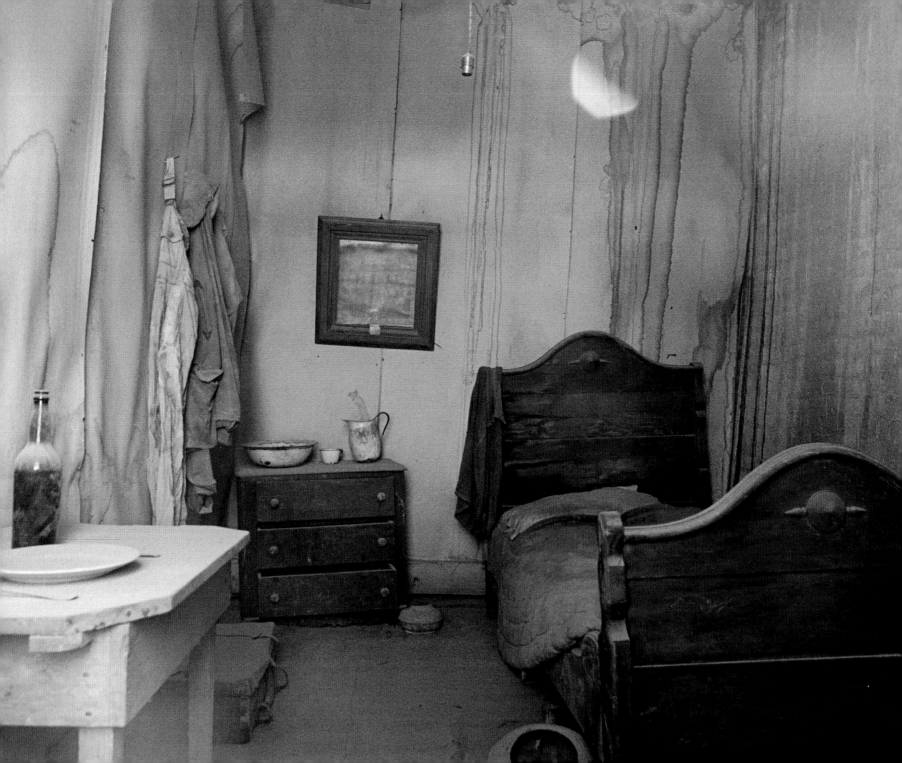

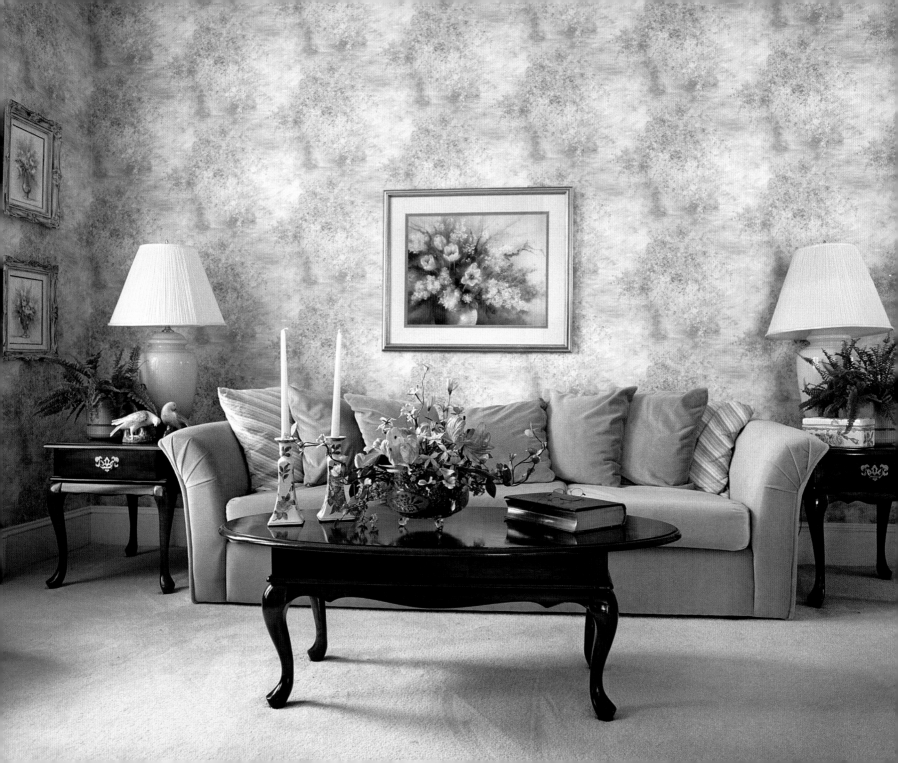

The House Remembers

Women, ghosts, and houses

One need not be a chamber to be haunted,
One need not be a house;
The brain has corridors surpassing
Material place.

EMILY DICKINSON

WHEN I WAS BETWEEN THE AGES OF FIVE AND EIGHT, MY SISTER AND I SLEPT IN A LARGE ATTIC BEDROOM. At nightfall the room was filled with gypsies, who glided around in clusters. They wore colorful, thin flowing dresses and rummaged greedily through my drawers and books as if they were seeking to reclaim their possessions. I lay in bed as stiff as a board, trying to will myself invisible, praying they would not notice me looking. Terrified and mesmerized, my eyes were fixed on these cold strangers, studying every detail and silent movement. My sister was only inches away from me in bed, but I was too afraid to turn my head and get her attention. Daylight obliterated the gypsies, rendering them as thoroughly insubstantial as they had been real in the dark. I had a vague understanding that my vision was private, so I never told my family what I saw. When I was nine, my family converted the attic into proper bedrooms, and I stopped seeing ghosts. But this experience has always influenced my belief that the numinous is a part of daily life and that it is possible to see what is usually considered invisible.

A long time ago, I enlisted the camera to explore invisible territories. Some might argue that the camera is not the most appropriate tool for this endeavor, and yet it is the medium through which I can connect with and make sense of this elusive world. I have faith in the camera's ability to teach us about reality and a sense of wonder at photography's capacity to transform the ordinary and reflect the mystery and strangeness beneath the surface. Through the medium of the visible, photography makes the invisible apparent. By collecting extensive evidence of the surface, one becomes aware of what is missing, and a space is provided for the viewer to imagine the invisible.

My venture into haunted houses began the summer following my college graduation. I was living in an old Baltimore apartment, where I passed the long hot days reading ghost stories by the female authors Edith Wharton, Charlotte Bronte, Ellen Glasgow, and Toni Morrison. In the stories I read that summer, the ghost functioned as a way to explore topics such as abuse, property rights, mothering, unfulfilled desire, and the porous boundary between inner and outer worlds. Many of the authors were Victorian and they were considered ghostlike themselves, alienated and marginalized by society. Their ghost stories have been interpreted as a means of voicing what they could not otherwise say. I wanted to further understand the relationship among women, ghosts, and houses, but I didn't want to escape into books like far too many women before me. Instead, I decided to use ghost stories as a means to voyage into the world, and

embarked on a journey to photograph the interiors of America's haunted houses.

I departed with restlessness, feeling both the freedom and uncertainty of being on the road. I felt most empowered and liberated when moving through the country's interior landscape. I traveled from a remote log cabin in Appalachia to an abandoned gold-mining town in the desert to a palatial Southern mansion to a New England farmhouse to a cookie-cutter suburban residence. In this way I built up various intimations of domestic space. The notion of *hauntedness* activates and highlights the home, revealing the hidden narratives and possibilities of everyday life.

Ghosts are commonly thought of as trapped in or attached to a particular house because they died there or because they love the house so much they do not want to leave. Some ghosts are believed to have consciousness and interact with the living. These ghosts sometimes aid humans, or seek justice. Other ghosts are more akin to trapped energy; they are "stuck" in time and repeat movements without purpose. And then there are the spirits that people see after the death of a loved one; these spirits provide comfort to bereaved individuals and help them cope with their grief.

Ghost stories often reflect the history of a region: female ghosts in Nantucket are said to be searching for their husbands who never returned home from whaling voyages, and ghosts from Gettysburg commemorate casualties of the Civil War. Ghost stories that have been passed down from generation to generation often encompass archetypal themes: unrequited love, devastated dreams,

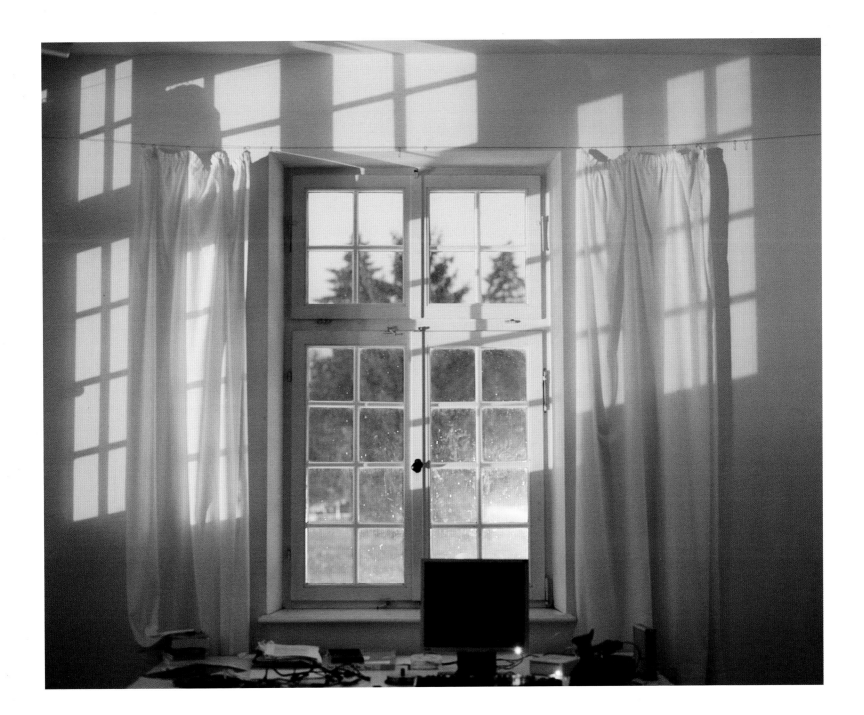

violent death. A common motif is that of a beautiful female specter who appears in white virginal attire. These female ghosts are often seen searching for their lost lovers or their wedding rings. Many are said to have died traumatically. These stories and visions underscore the pervasive imagery of erotic and frightening dead women in our culture.

I photographed legendary haunted houses, but I was most interested in photographing private residences and meeting the otherwise ordinary people who "live" with ghosts. When I visited private homes, I wanted to know how invisible presences are sensed, how ghosts affect people's sense of security, and what life is like in a haunted house. I would arrive at a stranger's house and politely request permission to photograph inside. As if they expected my arrival and understood their houses contained something essential to me, I was invited in and given free rein to photograph. People recounted their experiences within their haunted domains, and I collected these first-hand accounts using an audio recorder.

Stepping into a private space and listening to ghost stories opens the door to additional stories about families and personal histories. People confided about divorce, how they came to live where they did, and about daily life: people were bored, content, and lonely. A hospitable woman who lived with her grown daughter on the grounds of Rotherwood Mansion, which overlooks the Holston River in Kingsport, Tennessee, played classical music on the piano while I wandered through the mansion taking photographs. Before, after, and during her ghost story, a woman with silvery gray hair recounted how her husband died unexpectedly. She claimed that she didn't believe in ghosts, yet she was forced to because she saw them with her own eyes. A wonderful old Pennsylvania clock ticked loudly as I stayed photographing far past any decent hour. Another ghost story became a harbinger of tragedy. In Richmond, Virginia, I met a young woman who lived with her husband in a historic house. She had seen the ghost of the man who built the house looking at blueprints by the light of the window. She observed every detail down to his pinstriped gray flannel pants with cuffs, black shoes, shiny black curly hair, and wire-rimmed glasses. The following year she committed suicide.

The mid-nineteenth century saw the birth of both photography and the Spiritualist movement in America. The cultural climate was particularly fertile for Spiritualism, because religious beliefs had been thrown into question by science. Spiritualism began in 1848, when three young sisters turned odd rapping noises in their home into a game of spirit communication by asking questions and receiving answers with knocks for "yes" and "no." Adherents of Spiritualism wanted to use science to prove their religious conviction that communication with the dead was possible; thus, they enlisted modern technologies, such as the telegraph and the camera, to provide "evidence" of the afterlife. In early "spirit photographs," small faces surround the subject. One of the faces would be identified as a dead relative of the subject, and the others were said to be spirit guides. (The use of technology in response to the supernatural continues today, as ghost hunters

measure activity with electronic voice phenomena and electromagnetic field detectors.) The majority of Spiritualist mediums (those with the ability to communicate with spirits) were female, and the characteristics associated with successful channeling were the stereotypical feminine attributes of sensitivity and receptivity.

When I photographed in haunted houses, I continued the Victorian tradition of female receptivity to the otherworldly: I tried to open myself to the invisible nuances of a space. I listened and attempted to be at its mercy. The particularities of the houses moved me; each demanded an individual response. As the project progressed, my intuitive understanding of where to stand and photograph sharpened. I sometimes took as few as three images. Studying the interior through the ground glass was an alchemical process that allowed me a heightened experience of my surroundings. The large-format camera transformed my perception and slowed me down. The exposures were usually long, lasting anywhere from a few seconds to a few hours. After opening the shutter I would slip out of the room to wander. I thought of the room as a stage, and I felt there was a greater chance for something to happen in my absence. It was like leaving behind a magic box. As a consequence, when I developed my negatives, I was surprised by images that I had not observed.

Like a souvenir, my photographs are both mute and partial. They are connected to the sites through a story as well as through the indexical nature of photography: the film and the referent were in the same space and time when the image was captured.

The philosopher Roland Barthes describes photographic relationships of this sort as an "umbilical cord." In the moment of viewing, the photograph refers simultaneously to *This will be* and *that has been*. This is why photographic representation is linked to death, mortality, and mourning. If they had not been captured, the images and stories in this book would have floated away and vanished into the ether. Yet their concrete permeations are structurally haunted and suspended between reality and fiction: disembodied voices, silent words, the inherent ambiguousness of photographs, and the failure for either words or images to properly elucidate the world.

We All Have to Live Here Together

My spaces are fragile: time is going to wear them away, to destroy them. Nothing will any longer resemble what was, my memories will betray me, oblivion will infiltrate my memory, I shall look at a few old yellowing photographs with broken edges without recognizing them.

GEORGES PEREC
SPECIES OF SPACE AND OTHER PIECES

Houses collect impressions of past inhabitants, whether the subtle energy left by occupants, the knowledge of a violent event that occurred there, or the materialization of a ghost. When people move

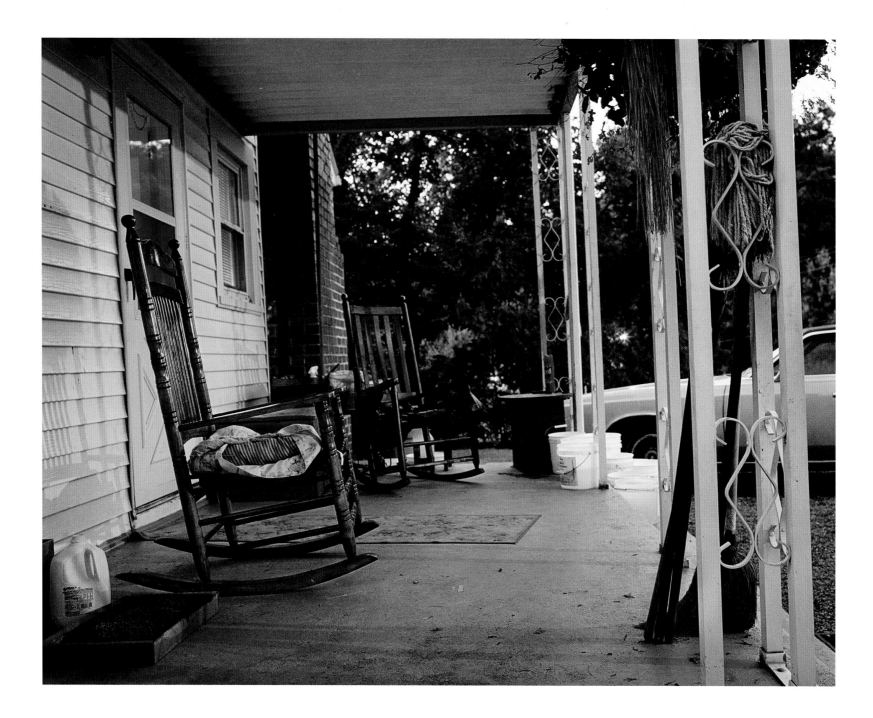

into a house, they commonly try to make it their own by cleaning or renovating it; some burn sage or get a priest's blessing. When they move into houses known to be haunted, people often acknowledge the ghost's right to be there and attempt to make peace with it, saying things like, "We all have to live here together" and "You have a right to be here, but so do I." Some people will not inhabit a haunted house. In 1989, a man purchased a Victorian house in Nyack, New York, that the owner, Helen Ackley, had publicized as haunted. Unfortunately, she did not specifically disclose this information to the buyer. After learning of the haunting, the buyer wanted to back out of the deal and sued for the return of his $32,000 down payment. The appellate court cancelled the contract and ordered a refund of his money. The case highlights the complicated issues surrounding houses, ownership, and ghosts. When we move into a house, we expect to take possession of it, and yet sometimes it has not been fully vacated and our lives become entangled with "other" inhabitants in unexpected ways.

We strive to create the home as a world unto itself. Feeling comfortable and safe in one's home relates to feeling in control. Doors, walls, alarm systems, and gated communities all exist to keep out real and imagined danger. The ghost is an interloper that undermines the notion of the house as private and contained, which is why in horror movies the ghost must be evacuated. Haunted houses are emblematic of Freud's notion of the uncanny, when the security of the home is rendered frightening and unfamiliar by outsides forces, repressed events, or memories. These dark, motionless houses secretly drain your energy. People describe feeling depressed and unwell living in these houses and often put off moving in; children are afraid to sleep in their bedrooms, and people blame the house for family strife and bad luck. Many people live in haunted houses—ghost or no ghost—that are marked by abuse and neglect.

But the majority of ghost stories I collected were comparatively mild. After the initial shock of encountering a ghost in the house, people came to terms with what they experienced. Many people felt they could live peacefully with the ghost as long as it was recognized and acknowledged. People accepted their ghosts and sometimes went so far as to admit feeling comforted by the sensations of never being entirely alone. The ghost can provide fun, excitement, and escape from the tedium of daily life. As one woman exclaimed, "Wouldn't it be boring if it was just us and there was nothing else?" People especially take comfort in the ghosts of their lost loved ones. One woman told me that she tries to be rational about all of the ghosts in her house except the one involving her mom. "I want that to be real. I want it to be my mom," she explained.

Sometimes the ghost is treated like a member of the household who is greeted, wished a Merry Christmas, and asked to protect the house. Ghosts watch over children, turn off lights, shut doors. One man described a ghost who woke him up in the middle of the night when there was something wrong with the house. One woman claimed that she believed if her house were being robbed, the ghost would scare away the burglars. People were amazed

by their encounters with ghosts; yet they also integrated these experiences into their home life, oftentimes taking their ghosts for granted. "My daughter was brought up with the ghost so it never bothered her. No one ever told her ghost or no ghost so it was like having a dog, it was just another thing," explained one man.

Many of the ghost stories I collected commemorate the lives of everyday, ordinary people for whom our culture does not typically erect monuments: Gertrude, of Merchant's House, who outlived the family fortune yet refused to let go of her family home; the servant girl Phoebe, of Sayre House, who was bludgeoned to death; a mother and daughter slave seen doing housework at Michie Tavern; a man named Oscar who is seen at a private residence in Maryland and who died on his way home from a tavern. Some ghosts lived quiet lives, some tragic, others we know virtually nothing about. These unknown, nameless individuals are acknowledged and symbolically rescued from being entirely forgotten by current residents who make a space for the ghost.

The ghost's attachment to the house reflects important connections between the self and home. The house is not simply a physical space; it is a structure that produces and contains our memories and identities. Ghosts are agoraphobic insofar as they are described as attached by invisible boundaries to the home, which serves as both a prison and a haven. Doug, the owner of the Orcas Hotel, voiced a common theme in his narrative: "This is Octavia's home. She had this place for forty years, she lived here and she died here, and she never had kids. The house is her baby."

The ghost cannot leave because of its emotional tie to the building; the house contains an essential part of its identity. In fact, the self and home are melded together so completely that renovations are thought to provoke and sometimes diminish the presence of a ghost. "I think the ghost is happy with me because I don't change the house much," explained one woman. Without the house, the ghost might cease to exist.

Real-life agoraphobics embody the stereotype that women are closer than men to the home. Agoraphobia is known as the "housewive's disease": it is estimated that 80 to 85 percent of agoraphobics are women, connecting this condition to gender inequalities. Domestic space in general has historically been described as the woman's domain, and the home is often described in feminine terms. Freud interprets the primal security we seek in the home as a desire to return to the first home: the womb. The impossibility of returning to a womblike unity renders the house as a womb-tomb. This Gothic feminized interior space is epitomized in *Jane Eyre*, in which a madwoman is confined to the attic. The theme of women driven mad by isolation or entrapment in a house is a mainstay of Gothic literature and ghost stories. Historically, the home has been a site of female oppression. Female ghosts entrapped within domestic space reflect the ambivalent relationship between the desire for protection in the home and the potential for suffocation and isolation.

The agoraphobic's codependent experience of self and environment is an exaggeration of the relationship everyone must

negotiate. It is sometimes impossible to clearly delineate between our perception and "objective" space. The blurring of physical and psychological boundaries is a hallmark of ghost stories and exemplary of Sarah Winchester's house in San Jose, California. After the death of her husband and daughter, Sarah, heiress to the Winchester rifle fortune, sought the counsel of a medium. The medium told her the spirits of those killed by the Winchester rifle were angry and that Sarah would be the next to die if she didn't appease them. For thirty-eight years, sixteen carpenters worked on the house day and night. In order to confuse the spirits, Sarah designed the house like a maze with 160 rooms, stairs that lead nowhere and doors that open to a three-story drop. The interior of Sarah's house seems codependent with her mind, constantly changing directions, paranoid, hidden, and impossible to grasp. Her house twists Martin Heidegger's creed around, "Only if we are capable of dwelling, only then can we build." Sarah believed that only if she built was she capable of living. It is said that when she died the builders stopped working immediately, leaving nails halfway hammered into walls.

Similar to ghosts that return home, it is not uncommon for people to return to their childhood home (or houses where they spent formative periods) and ask the current owners for permission to come inside. We walk through these houses as if we are trying to find a lost self or are expecting to bump into our youth. Those who, in the words of Thomas Wolfe, "can't go home again" feed their memory and imagination on nostalgia for their formative spaces. For the author Georges Perec, the loss of a stable home and identity meant that space is constantly negotiated and experienced: "Such places don't exist, and it's because they don't exist that space becomes a question, ceases to be self-evident, ceases to be incorporated, ceases to be appropriated. Space is a doubt: I have constantly to mark it, to designate it. It's never mine, never given to me, I have to conquer it." In a haunted house, unexpected smells, sensations, and forgotten histories rise from beneath the surface of normal life and take hold of us, reminding us that space is an unending negotiation between our phenomenological perception and the outside world. In this sense, we are all haunted.

During the seven years I photographed for this project, I lived in eight apartments in New York City as well as two houses and a barn in upstate New York. I also lived in the haunted houses I visited. I dreamt of houses: living in other people's houses and wearing their clothes, walking through palaces and burning them down. I was in the basement with my dad when my childhood house began to cave in: it was the end of the world. I arrived at my friend's house to record his ghost story but he was not there, so I sat down and had tea with his mother instead and we talked about her son. She didn't know where he was, and she was worried that he would not come home. I woke up and realized that I was talking with a ghost: my friend's mother died when he was twelve. I was not looking for a lost home or self in my travels, but by traveling and viewing others' lives, I developed the capacity to feel at home everywhere and nowhere; by the end, I felt as if I inhabited my own being more fully.

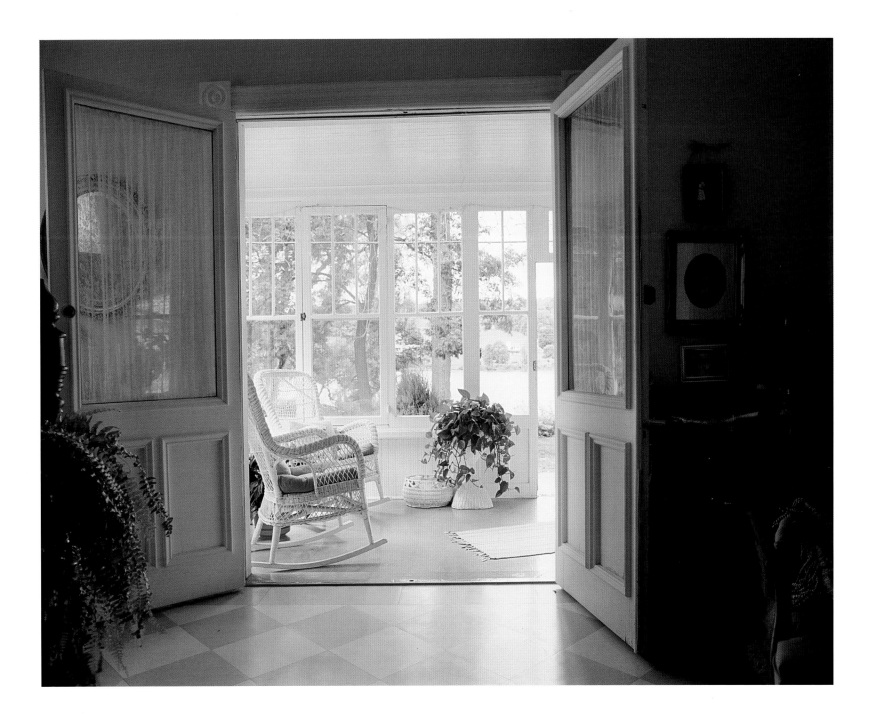

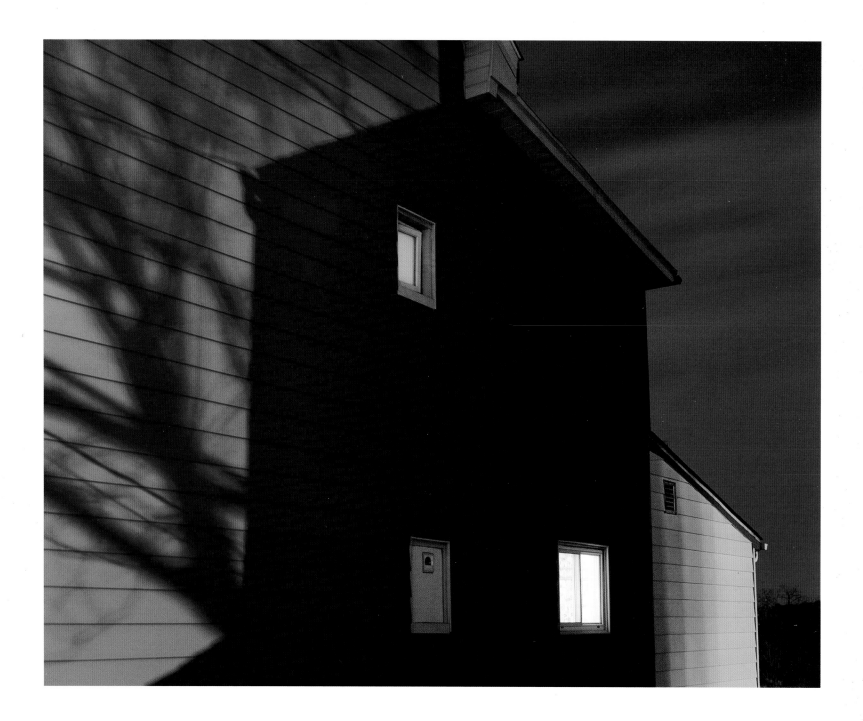

In this book, I present stories and photographs; both are necessary, but each is incomplete—a relic, a fragment, almost lost, half-remembered. A man begins his ghost story, "I don't know. You'll just have a sense or a feeling." A woman ends hers: "I still don't understand why she came and what it meant." A child's laughter, a slight breeze, twelve cups swinging back and forth in unison, twenty-five pounds of sugar go missing, a computer types by itself, and books fly everywhere. . . .

Houses are real and they are not real; they are both a physical space and a mental space full of dreams and desires. The house remembers. It is filled with sorrow, longing, happiness, and love. You do not have to believe in ghosts, but I invite you to move through these haunted houses in a state of wonder. You pass the spot quickly, you return, you run to the attic, moving from one room to the next, fluttering between the lace curtains, resting on the cozy yet somewhat tawdry chair. You glide down the banister laughing, and you dance through the kitchen. As you wander through these spaces, you may come into contact with a hidden part of yourself or suddenly "bump into a rememory," as Toni Morrison put it. Haunted houses remind us that, through the spaces we inhabit, our lives intersect with those of others long gone.

We are all subject to the same fate—change and decay, life and death—yet we do what we can to resist oblivion. We build walls and live inside houses, we try to make these interiors as safe and comfortable as possible, we hold our loved ones near. We sometimes wish that we could freeze a particular moment—a lover's embrace, an infant sleeping peacefully—forever. We sweep floors, wash windows, and lock doors. Sometimes the door will not stay shut, and it comes as little surprise that the dead have returned to visit. We are willing to share our homes with ghosts, however, because in the unimaginable future, we hope the door will be open to us, that we will be remembered and invited inside. I invite you inside.

FOLLOWING:
Abandoned House, Frankfort, Maine
El Rancho, Las Vegas, Nevada
Private Residence No. 1, Skowhegan, Maine

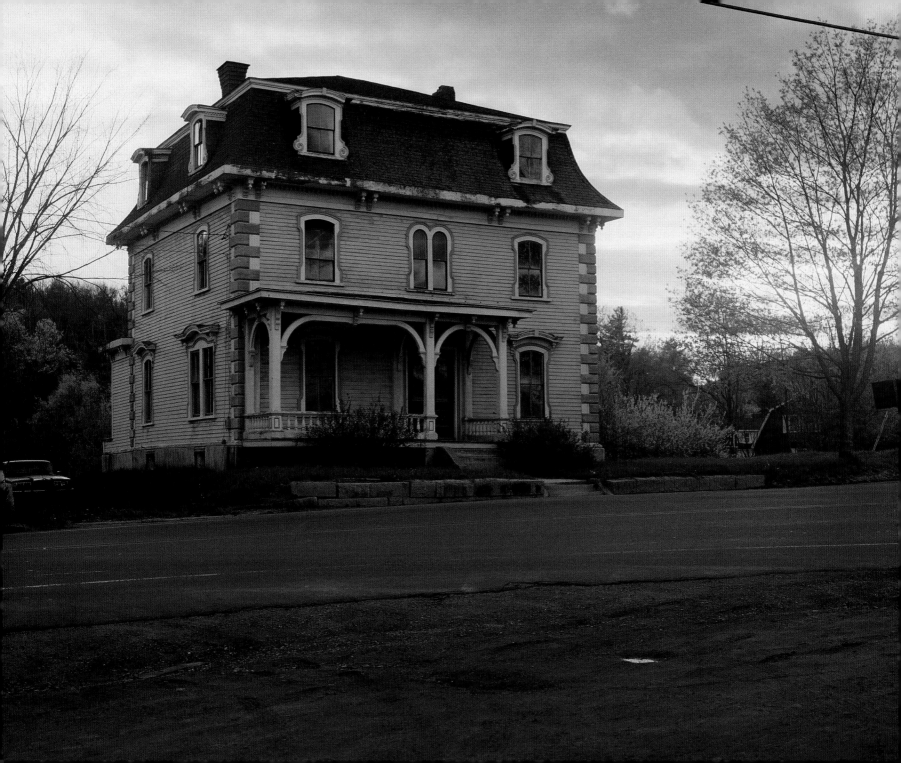

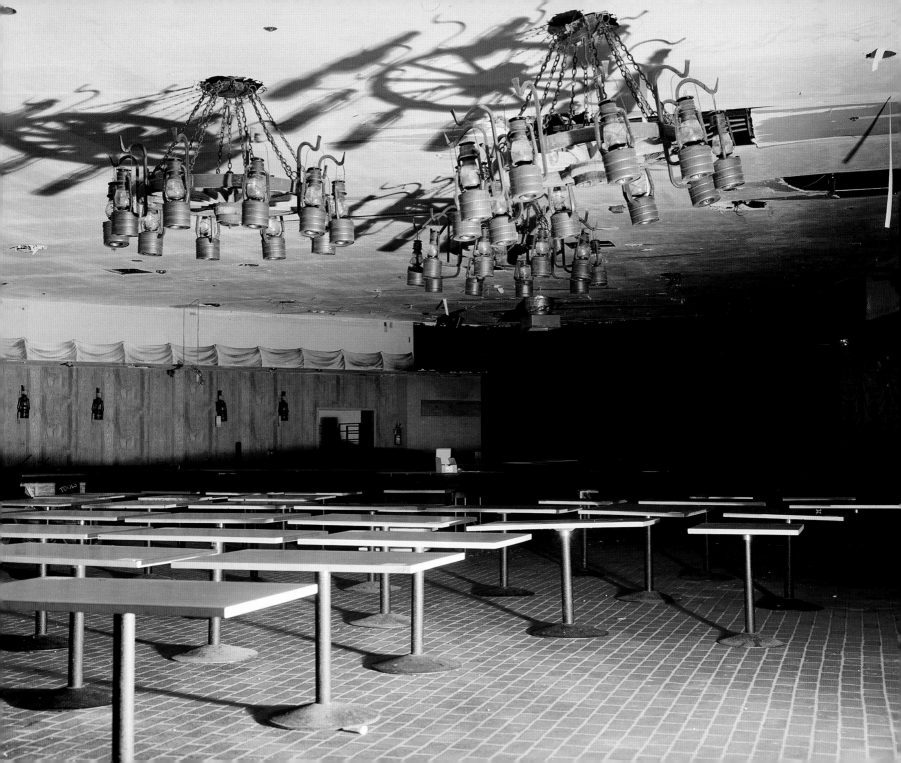

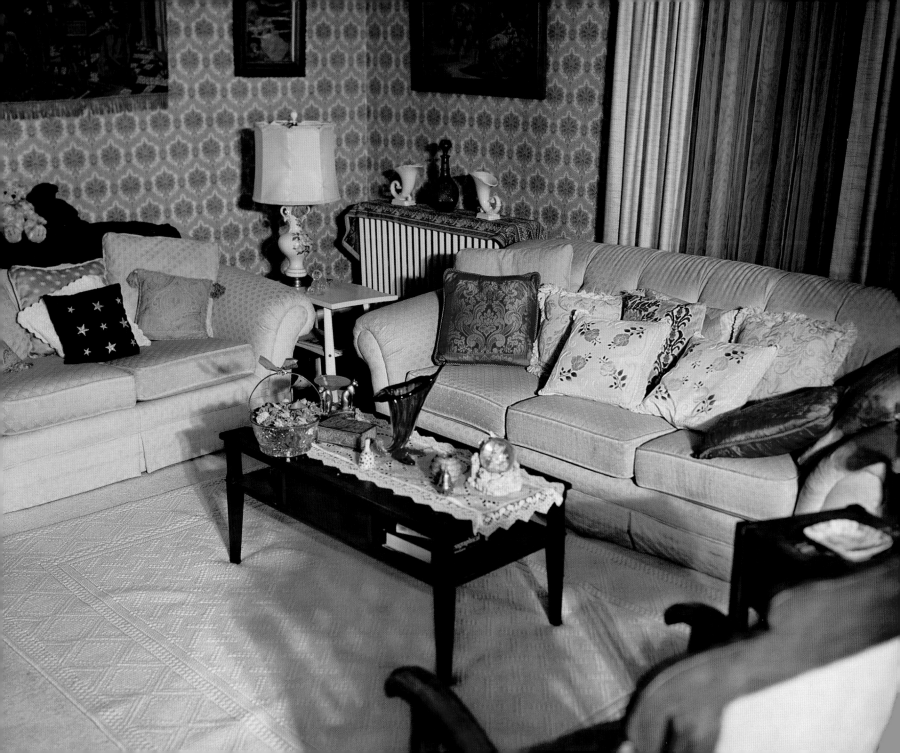

I WAS COMING DOWNSTAIRS AND THERE WAS A GENTLEMAN WALKING FROM THE LADIES' PARLOR TO THE GENTLEMAN'S PARLOR, and I thought it was quite odd because we don't walk that way on tour. So I went upstairs to catch him and all I'm noticing is his great hair. It was a brown curly hair with the goldest gold tinge to the top and sides that I have ever seen in my life. He had his arms crossed and he was looking up at the coachman's hall, which is in the hall right by the door. I was trying to catch him, but he was moving fast; I started to say, "Excuse me, sir," when suddenly no one was in the room. He had on gray slacks and a very beautiful blue waistcoat. I saw no flesh because his arms were folded and he was looking in a different direction. It dawned on me within seconds what I had seen. We never see through

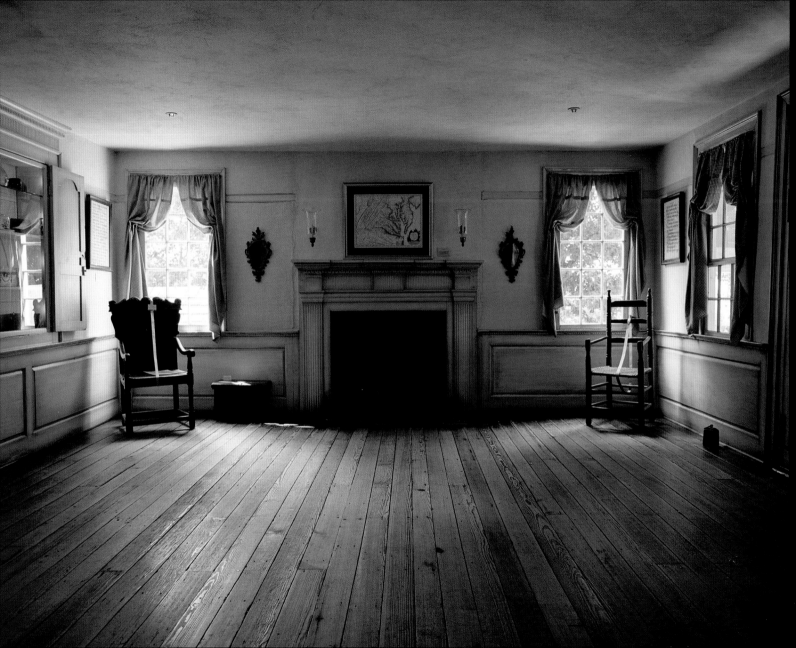

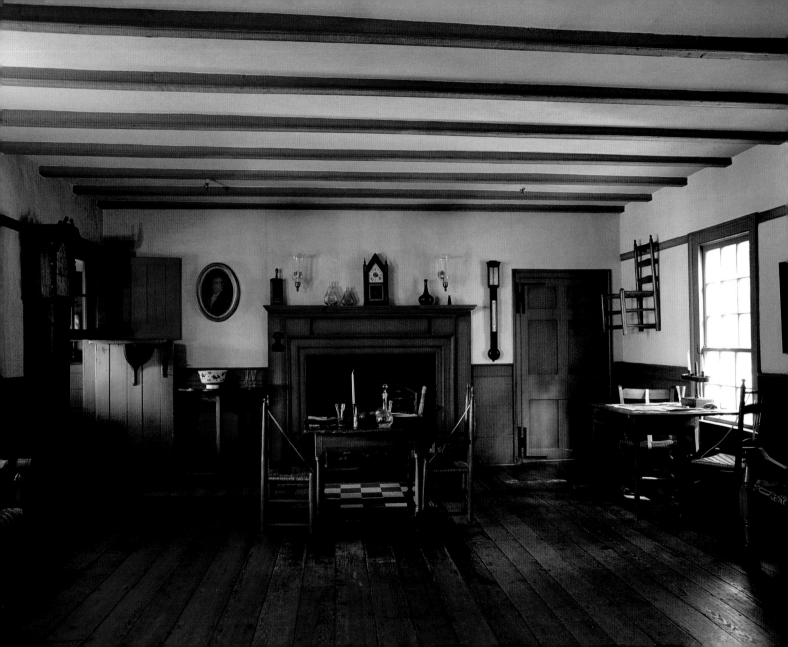

things, it's always a solid body. It's like watching someone when you're watching a movie. I have had other occurrences in this room here and in the gentleman's parlor, where I saw a woman and a girl walking in front of the fireplace, and I instinctively knew it was a mother-daughter slave. They were in full dress: the poof skirt, the holding

my tour said, "You're seeing something." At that point I turned to her and then I turned back and they were gone.

All of the ghosts are steadily doing their job and working except for the gentleman. The women are doing housework, dusting, cleaning, or carrying trays. You could ask me right now if I believe in

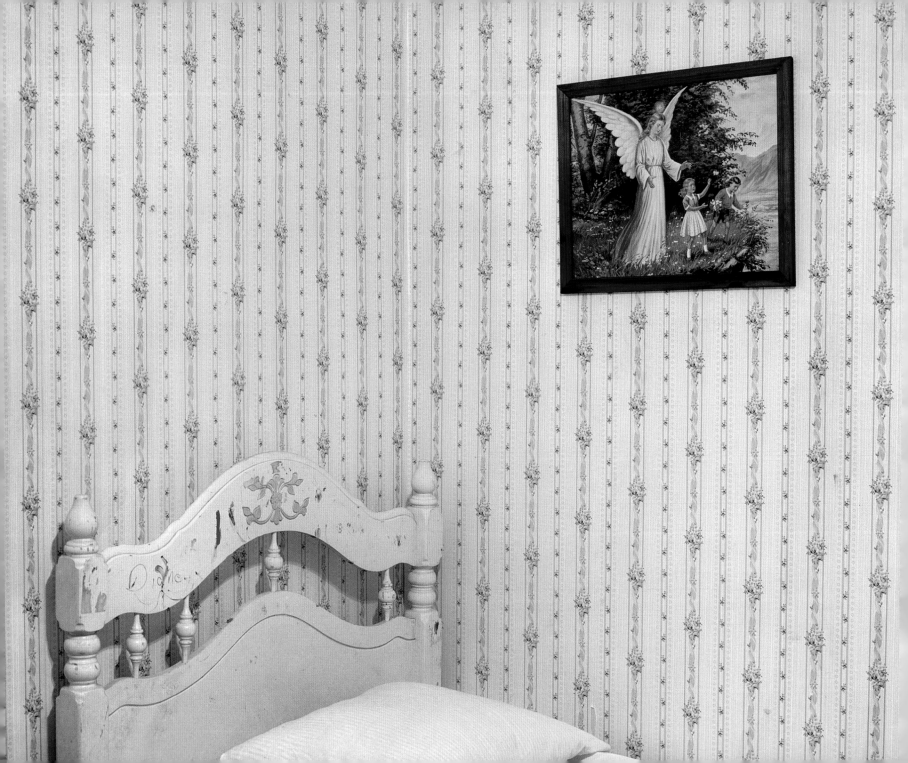

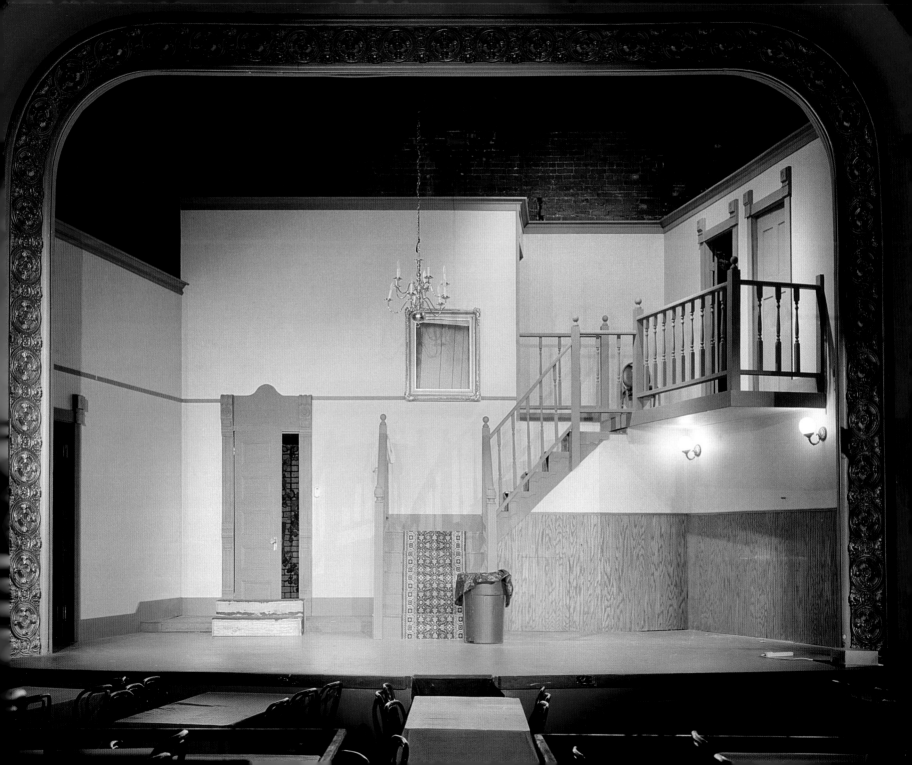

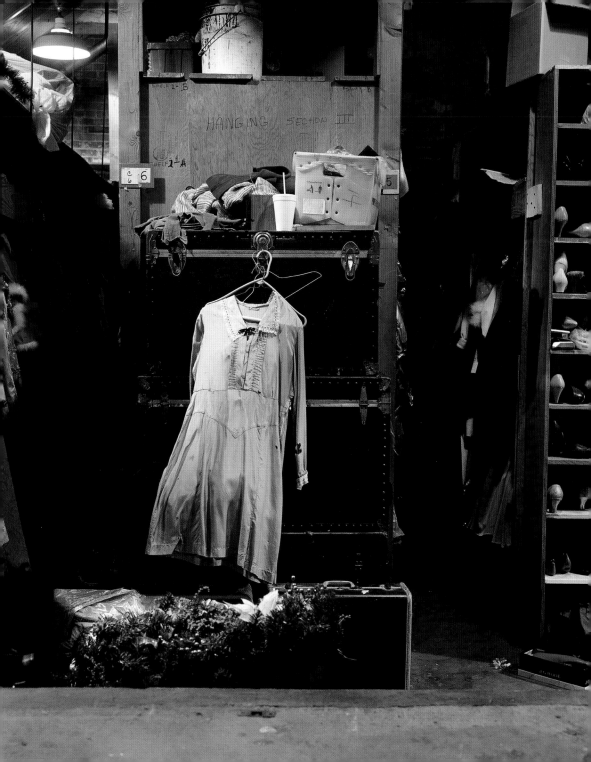

Private Residence, Niagara, New York

JASON

LIVED IN THE HOUSE FROM THE TIME HE WAS BORN UNTIL HE WAS FIFTEEN YEARS OLD

SOMEONE WOULD WALK UP THE STAIRS EVERY NIGHT, WALK DOWN THE LONG HALLWAY, LOOK INTO EACH ROOM, AND THEN GO INTO THE ROOM AT THE END. My mom always kept the door to that room closed and she stored things like Christmas presents there. She never explained to my brother and me why we shared a room and couldn't have that one. It was because she knew that every night the same thing happened.

One night my mom woke up and the woman came into her room and sat on her bed. My mom said she could see her perfectly. Her lips were moving like she was saying something, and my mom started to cry. The woman left and continued to walk down the hall looking into each room, and then she went into the room at the end. Mom just cried and cried. My father used to

My mom said that when we were two and three
years old she would hear a baby crying.
She would go check on us and we would be dead asleep.

work nights, so she called her father who stayed in the house for the next week until my dad switched off the night shift.

We would tell my mother about what we saw and she would say, "No, no, no." My mom didn't want to scare us, and we were Catholic so we weren't supposed to believe in stuff like that. We ended up thinking we were crazy. About four or five years later we were living in a different house and my brother and I decided to bring it up to my mom. She told us everything. My brother and I knew exactly what the woman looked like. We asked my mom and she described the exact same woman. It was really nice to hear my mom admit it. We were the only people who owned the house outside the family that built it. My mom said the one woman who lived there before us had died in the house during childbirth, and the baby died too. My mom said that when we were two and three years old she would hear a baby crying. She would go check on us and we would be dead asleep.

All of the instances are burned into my head. There were bells on the hutch that jingled by themselves. We would turn off the TV and it would turn back on by itself and start flipping through the channels. The dogs would stare at certain things and growl. I would see people walk by out of the corner of my eye. The woman did what she did every night, and it seemed like what she was supposed to do. She made no noise. It wasn't that scary because we learned to expect it after a while. But the other people in the house bothered me because they seemed more sneaky.

I was never comfortable in the house and there was such a relief in my body when we moved. My friend still lives across the street and when I go to visit him I don't even look at the house, or I look at it from far away down the street. I still have dreams where I'm standing in front of the house and the ghost is sitting at the window looking out. She's an old Italian woman wearing a housedress and she's watching me, almost like she's happy to see me. It upsets me horribly.

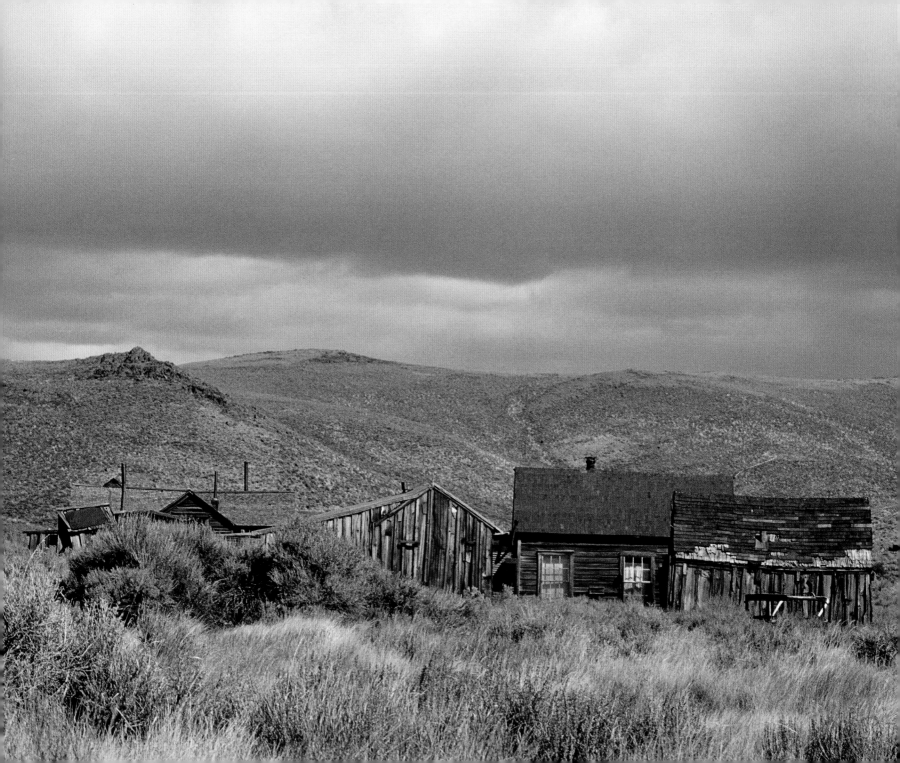

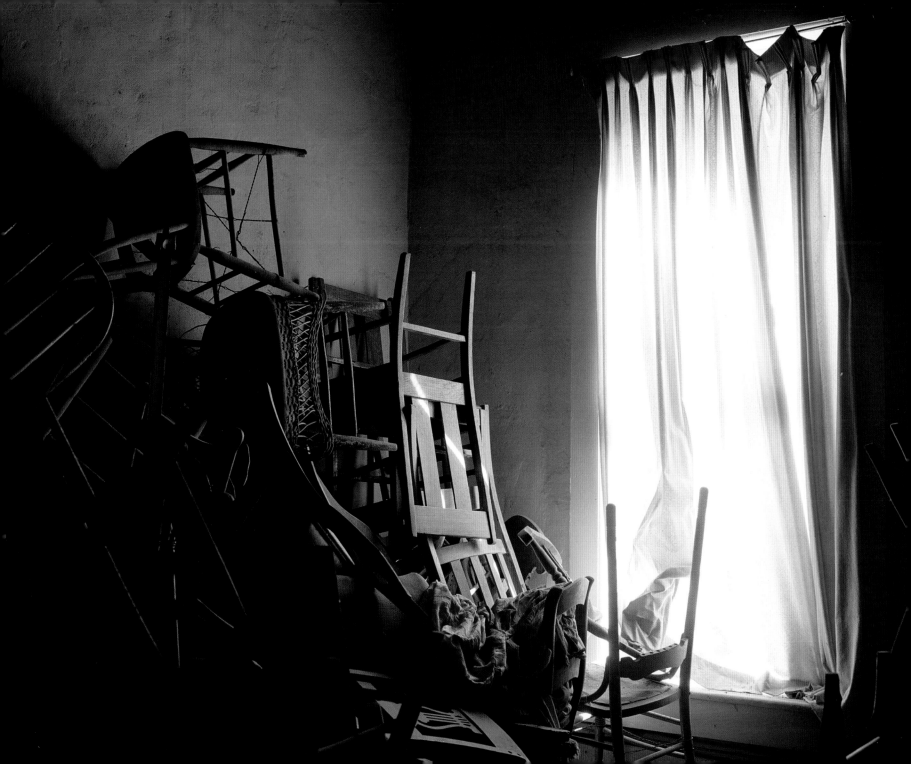

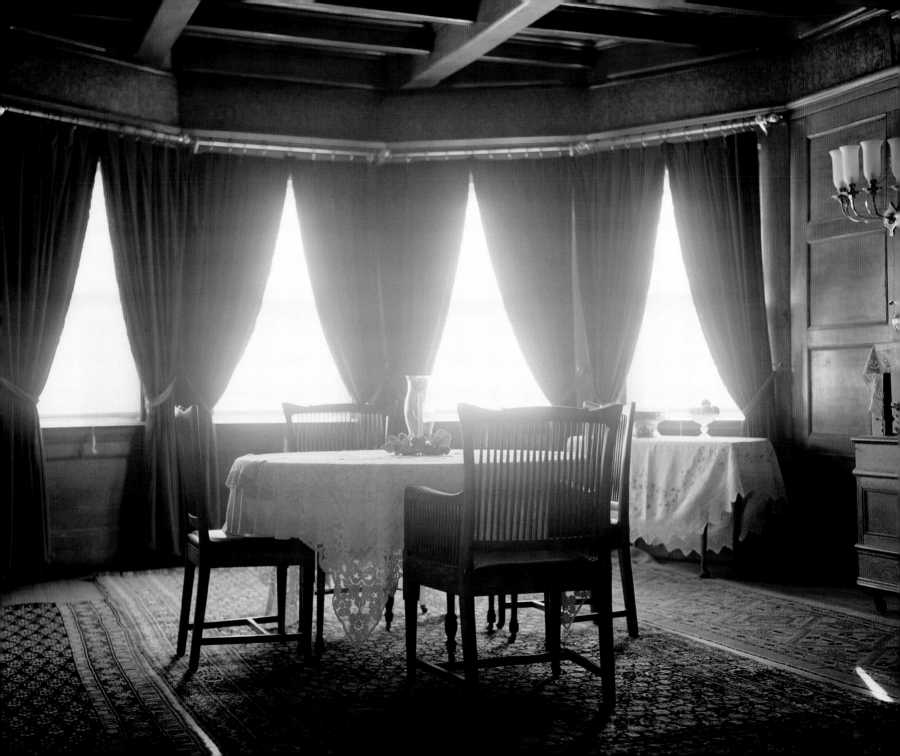

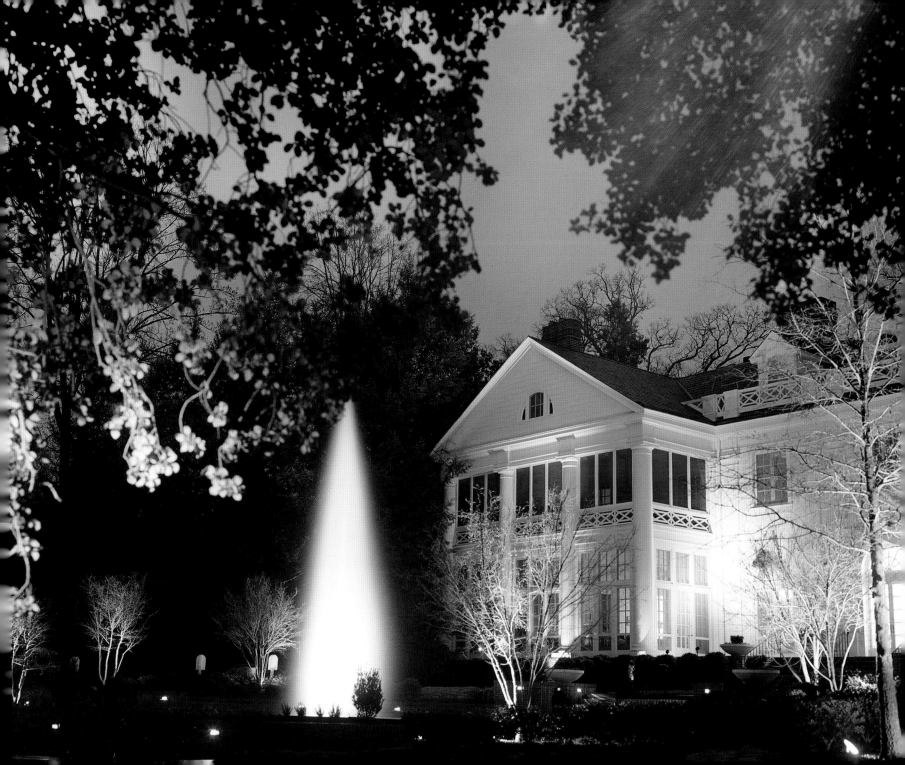

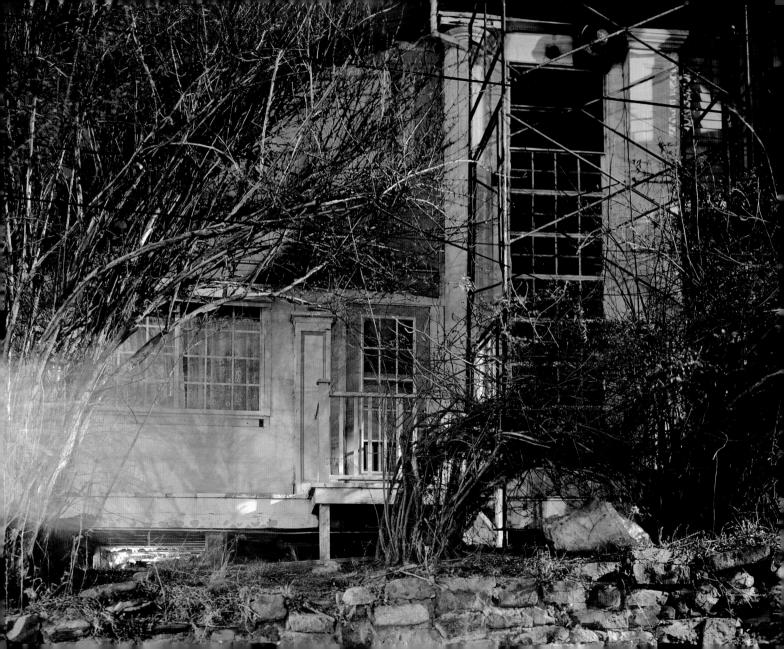

MARTHA AND HER HUSBAND LIVED IN THIS MANSION IN 1863. Martha's husband was off in the Civil War for two years, and he did not come back. He was missing in action and the body was never found. All of Martha's letters and pictures came back. She was very upset; she had no friends or family. She committed suicide; they found her in her bedroom closet. Martha did die of a broken heart—very pretty girl, very sad story.

Staff members have seen her floating around her house that we use as a restaurant now. We have an original mirror that dates back to 1863. One of our guests saw a vision of her through the mirror. She was smiling down at this particular guest, and they were really touched by it. Sometimes Martha gets mad. Staff members say that she burned a painting of herself that hangs

Staff members say that she burned a painting of herself
that hangs in the restaurant area.
There's a big burn going right through it.

in the restaurant area. There's a big burn going right through it. We sometimes find that there are dishes on the floor in the kitchen, after the kitchen was left very clean by our staff members. When we shut the chandelier lights off, one light flickers and never goes off. Mike, my manager, happened to be upstairs in the bedroom looking for something and he got a chill right through his body. He jerked because she went right through him.

I have not experienced seeing her, and I don't really believe in it, but she was pretty and I feel for her because she died of a broken heart. When I pass by I always say, "Hi Martha."

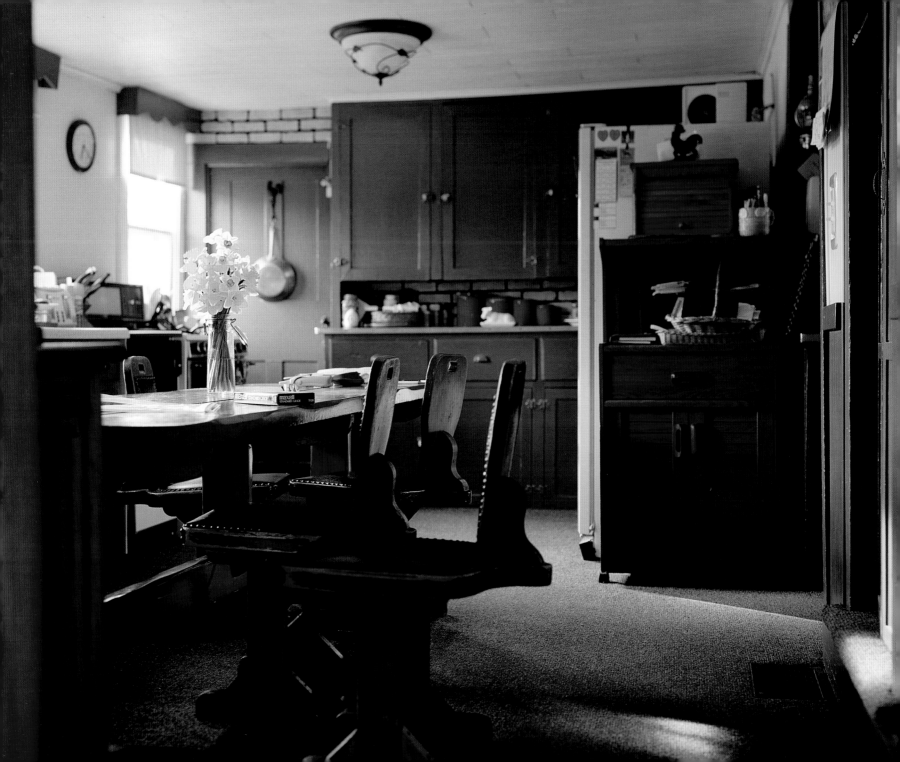

Farmhouse, Girard, Pennsylvania

VEE

WHO HAS LIVED IN THE HOUSE WITH HER
HUSBAND FOR MORE THAN FORTY-FIVE YEARS

THIS FARM IS ON THE MAP OF 1865 IN ERIE COUNTY, BUT THE BEIGERTS WHO LIVED HERE THEN HAD ALREADY BEEN HERE AWHILE. They had quite a few children and in the 1930s the elderly brother and sister were still living in the house when a horrible murder took place. The brother was attacked in the barn. The sister was attacked in the kitchen. They were found the next day by a man that came to tag the ears of their cows. The brother had been pitch-forked many times, and he was unconscious, but still alive. So the man went to Gerard and brought down the sheriff, and they found his sister on the kitchen floor, dead. The ambulance took Mr. Beigert to the hospital in Erie but he either died on the way, or he died there. That was the end of the family that had grown up here.

Throughout the years after that people did not live here very long because we didn't have a paved road. It was very difficult to live here in the winter because in our Erie, Pennsylvania, storms you don't get up that hill. Most people were unwilling to cope with that, and they left. We moved in here in 1963, and we've raised six children here. When we moved in we knew about the murder, but we didn't share that with our very little children to scare them half silly, because we were three-quarters of a mile from any neighbor. I have had absolutely no fear since day one of living here. There's none of that "Oh my god" feeling. Nothing happened that I'm aware of until my son who was about eight or nine years old came down the stairs and said, "Mom, I don't think that's very funny." My son never sassed me, and to this day he has never sassed me. I was trying to get all these kids ready for school and I didn't know what he was talking about. He said, "I just don't think that was a nice way to wake me up." "Will you tell me what you're talking about?" I asked. So he took me upstairs and showed me deer horns on the bed. Over his bed was a beautiful rack of deer horns, and what was unusual was that the deer horns were now on his bed, and he had rolled onto them. He thought that I had put the deer horns there so he would wake up. Of course I hadn't. But the hole on the plaque that held the deer horns was smaller than the nail head that was driven into the stud in the wall. So we've never been able to figure out with the nail still in the wall how the deer horns got off his wall and onto the bed. That was the first thing that we couldn't explain.

It was the night before Halloween. In the middle of the night we were lying in bed, and all of a sudden this roar starts, and we were awoken. The noise from a hurricane sounds like the engine of a train coming toward you, and we have a railroad that comes through here so we know what an engine sounds like. The first thing I think is one of the engines is coming down off the track, through the field, across the pasture, and into the house. But it would have rolled off the track before that ever could have happened so your mind says, "Wake up, wake up." It sounds like the train is coming, but it can't be. Then, I thought it must be a tornado. I grabbed the sheets because I expected my bed to start twisting. It went on and on and the noise just wouldn't stop. I thought, how long does it take for a tornado to finally get inside your house and destroy it? And then, after what seemed like forever, it was over. We lay there for a minute just to see if we were still alive, and my husband's voice really quietly said, "Is it Halloween yet?" which made us laugh.

We sat up and looked around, and there wasn't one thing on our bed. Books had flown everywhere—they even went out the bedroom door, made a right-hand turn and went up eight steps. All the little statues were gone. The hurricane lamp and music were missing. We thought, why isn't there anything on our bed? It was like we don't really want to hurt you but we're kind of ticked, we're not happy and we want to get your attention. The next thing I thought of was why aren't the kids terrified? There was no noise upstairs, and the dog didn't come down. The kids came down the next morning and I said, "Did you hear anything last night?" They said, "No." They had never heard that tremendous noise. It took me three days to get our bedroom back in order, to coordinate things back onto the shelves, and vacuum the broken glass. That was an oddity that we've never been able to understand.

When I would get exceptionally tired, I'd go upstairs to nap in my daughter's room. Nobody would be able to find me there. I noticed something when I was in her room, but I never told anybody

> She said it was very comforting, like another sister.
> Just this movement of going past, everyone's content,
> and she said she was never frightened.

until my daughter moved into her first apartment. I said, "Do you want your lamps?" And she said, "Oh no." I started to smile and said, "Why don't you take your lamps?" She said, "You wouldn't believe me if I told you." I said, "Yes I would because I know what they do." "What do they do Mom?" "They vibrate. They move." When they vibrated I would think, I'm just waking up, that's what it is, or the train's coming, but I'd put my hand on the wall and there was no train coming. I'd watch those lamps move. We never understood why they'd move. She didn't want 'em and I didn't want 'em either.

My daughter to this day swears that she saw her go back into the smaller room upstairs. She said it was very comforting, like another sister. Just this movement of going past, everyone's content, and she said she was never frightened. One morning she came down and said, "What did you want last night? Why didn't you just tell me?" She said she felt the mattress go down but she had been sleeping, so she woke up and noticed that it was indented as if I had left, but the mattress did not come back up, like someone sat on there and was with her. I had not been in her room. My daughter says that when she moved out of the house the ghost went with her. She said she just

knows she's there. She said, I know what I feel, and the presence went with me because I liked her the best.

A townsperson shared with us pictures of the murder that took place in the house. Before that time we didn't have any proof the murder happened. It was a story that we had grown up hearing from grandfathers and uncles. You believed it because everyone had pretty much the same story. After we saw the photographs we understood the horror of what had happened to them. I mean they were innocent, fine, farming people. To have this happen to a brother and sister who lived here is horrible, there is no excuse for it. But it almost seemed to me that once we knew how hard she fought, she put up a battle, rightfully so, it was like finally somebody understands, finally somebody knows how hard I fought and how unfair this was and now I'm at peace. It was like she couldn't leave until it was settled. We've been here longer than anyone has ever been here except for them, so maybe she feels like these people are real, they're here, they homesteaded, they have their animals just like we did and I'm content. Maybe she's gone on now.

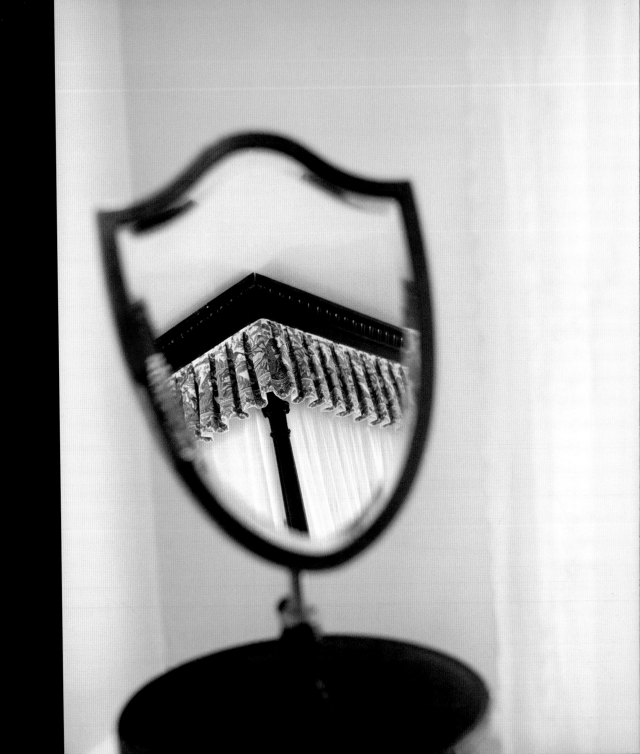

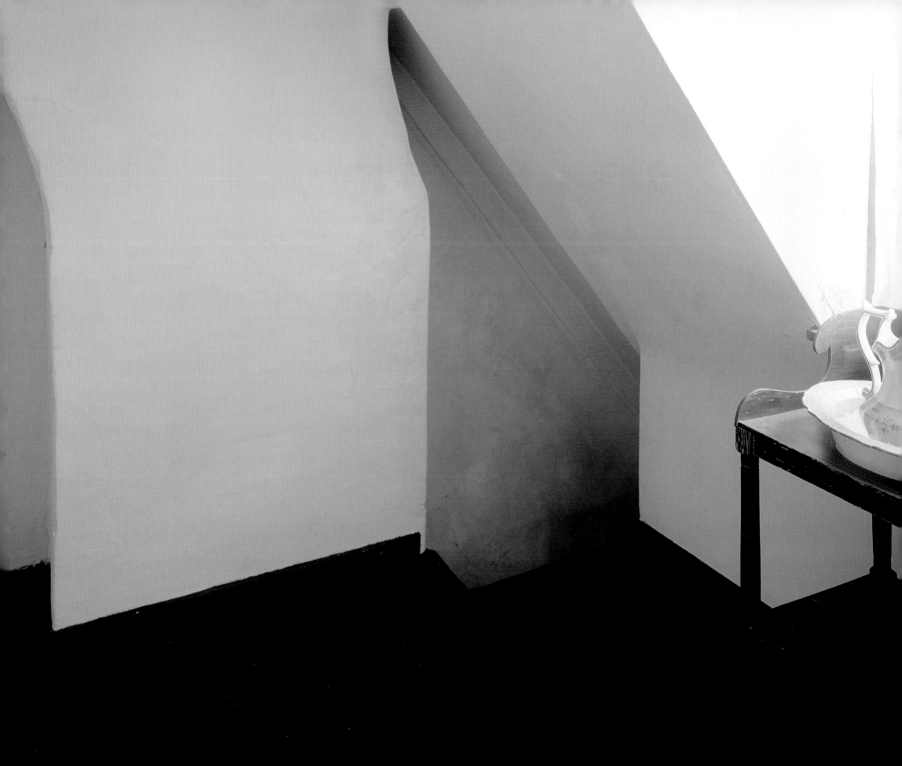

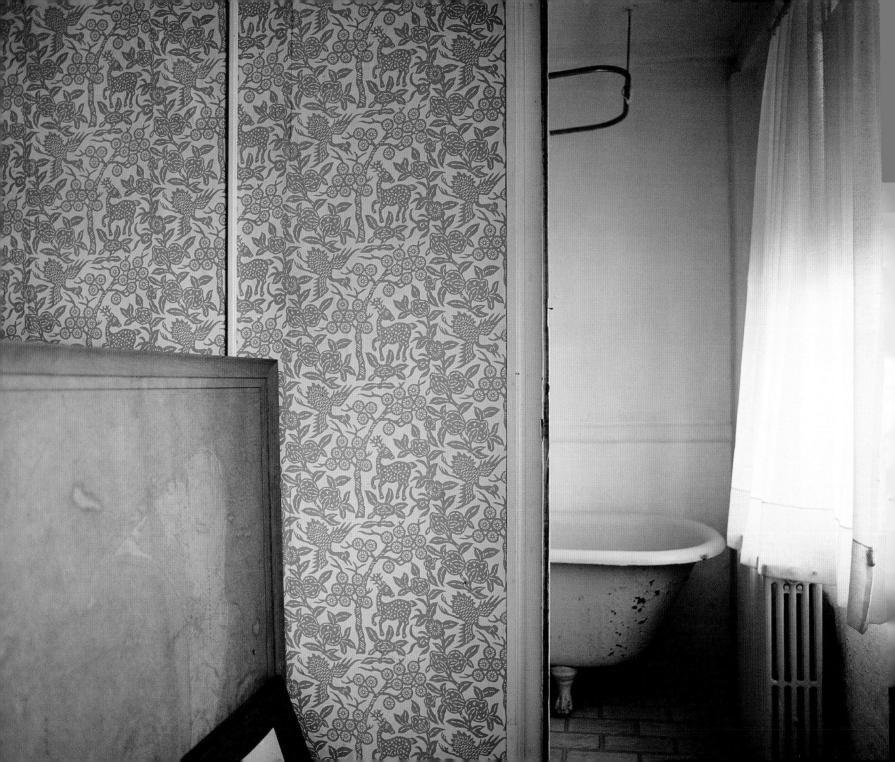

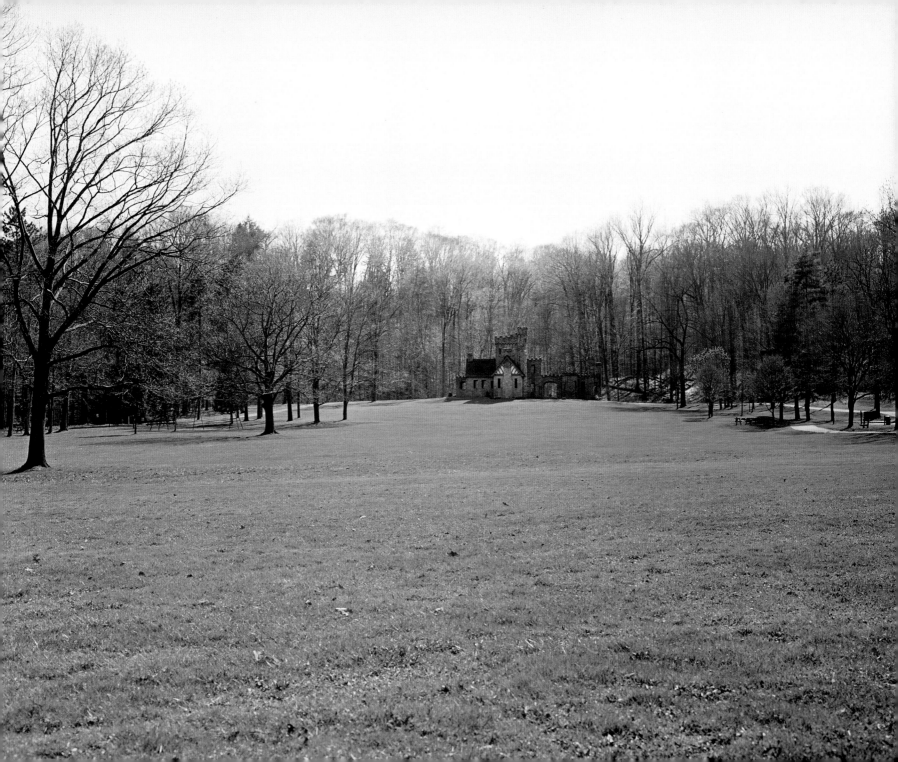

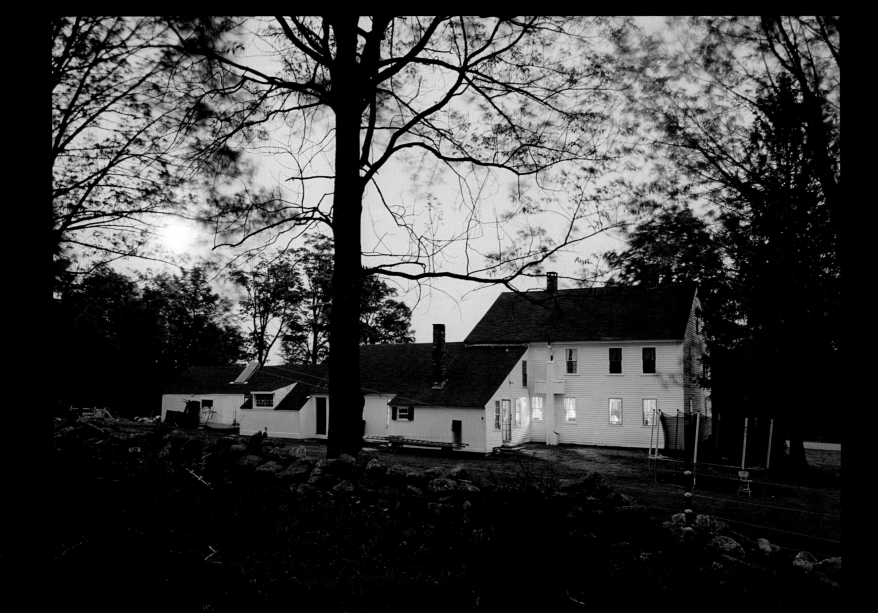

Farmhouse, New Braintree, Massachusetts

JOHN H.

THE PROPERTY HAS BEEN IN HIS FAMILY SINCE 1753; THE HOUSE WAS BUILT IN 1815

I WAS THERE ONCE BY MYSELF WATCHING THE HOUSE AND I HEARD SOMETHING WALKING UPSTAIRS. I went up and I didn't see anything. Then I was outside and I could hear steps walking up and down the stairs.

Every tenant has their own story. There were two women living there and they said, "We're out!" They wouldn't stay there because the furniture kept getting moved upstairs. The tenant living there now told me that he clearly saw a woman upstairs. It's a big old house and there are a lot of noises that are real and not real. Your mind can wander and it's a great environment to fester great stories so the legend grows and accumulates.

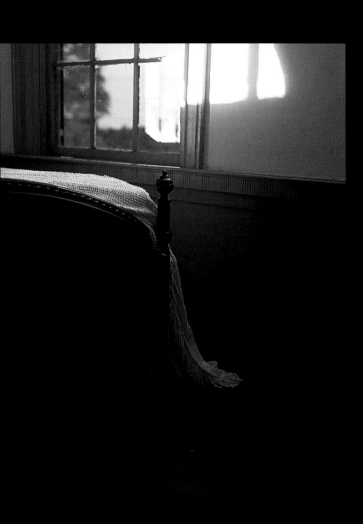

A CARETAKER OF THE HOUSE
WHO LIVED THERE FOR TEN YEARS

BEFORE I MOVED IN I MET WITH THE OWNERS, and they told me that a ghost named Aunt Lucy haunts the house. Lucy was a relative of the family; she never got married and died in the house. Of course, I was skeptical. Then I talked to the caretaker before me and he said, "Oh yeah, things happen."

We moved in and the first night we were there it was sort of spooky but not really. Before the first week was over and up until the first year I wouldn't go into the building alone at night. I'd wait for someone else to be there. Things started to happen. For instance, I'd put my wallet on the bureau the same way I do every night but when I'd wake up in the morning it wasn't there. Weeks later, it would turn up in the same place I left it, nothing gone, nothing missing. Another time she took my favorite spoon. It disappeared and reappeared on the same day.

Within a year of being there I got used to those behaviors: doors would open, doors would shut, the vacuum would shut off, things disappeared. Out of the corner of my eye I would see somebody walk from the living room to the dining room. I'd turn and nobody would be there. Or I'd be walking up to the house and I'd swear that somebody was walking through it. I'd walk through the house and look, but no one was there. I thought I saw her one time. I said, "Whose that woman walking through the house?" I chased her up the stairs, but no one was there. I knew Lucy was there all the time. No one could convince me otherwise.

By the time I left the house, Aunt Lucy was more like a roommate than a haunting spirit. She would do her thing and we'd

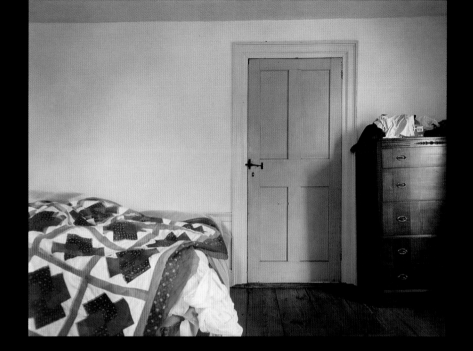

do ours. Saturday was a cleaning day and we'd say, "Hey Lucy, how ya doing today?" We'd get home and greet her. If something was missing you'd say, "Hey Lucy, I need those keys back." And they'd turn up really quick. I'd hear people walk across the floor all the time, I knew it was Aunt Lucy and I wasn't afraid so I'd go back to bed. Only when I'd wake up in the middle of the night did I know there was something wrong. One time Lucy got me up to tell me there was a chimney fire, another time she wanted to warn me that a horse was sick.

My daughter was brought up with the ghost so it never bothered her. No one ever told her ghost or no ghost so it was like having a dog, it was just another thing. One of the things about Lucy is that she liked to have us working. You had to do the dishes. I miss her but I don't miss all the work.

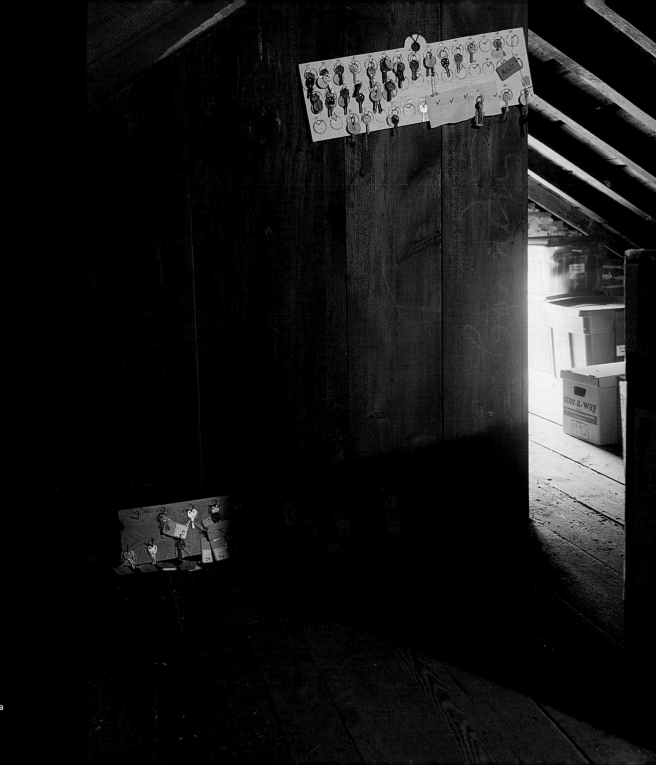

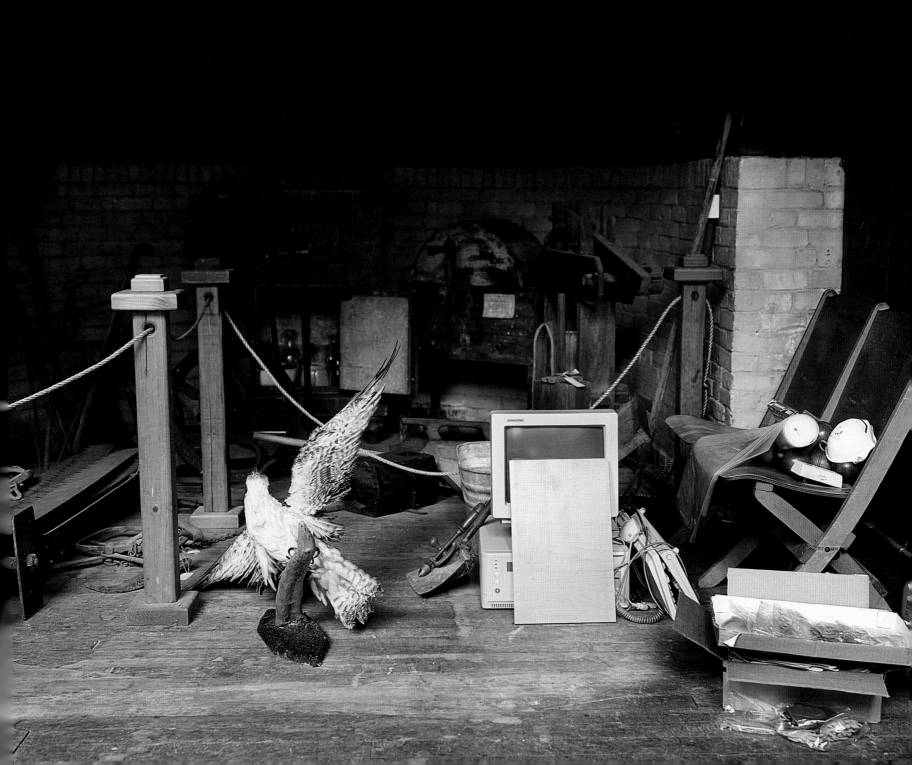

La Casa de Estudillo,
Old Town San Diego State Historic Park, California

KATHRYN

WORKED FOR FIVE YEARS IN OLD TOWN
STATE HISTORIC PARK

PEOPLE THINK THERE ARE ONE OR TWO GHOSTS AT LA CASA DE ESTUDILLO, but the entire family lives there. There are at least twenty-one ghosts, and there are spirits from other buildings at the park that come over to visit. The Estudillos are happy people; they are very loving, and they like to joke. Before I had an encounter there, I could feel them watching me. I was new and they weren't accustomed to me being in their house. So when I started opening the place up I said, "Buenos dias, las familias de Estudillo." And at night I said, "Buenos noches." They finally started answering me.

I was standing at my station looking into the garden courtyard, and there's a fountain in the center. All of a sudden, I noticed movement. I shifted my eyes and there she was. She

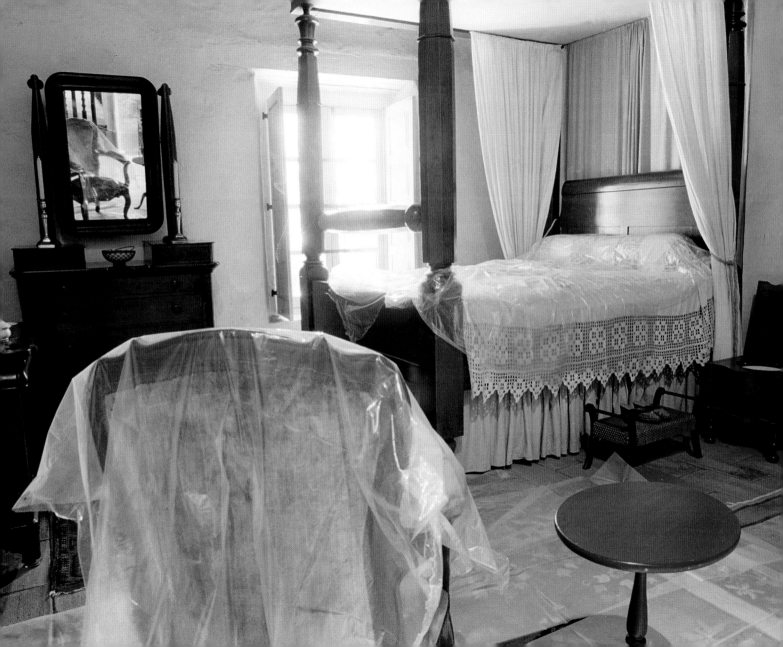

Before I had an encounter there, I could feel them watching me.
I was new and they weren't accustomed to me being in their house.

walked very rapidly across the garden. At first I thought it was a new aide that I hadn't met yet, because she was in period attire, of course, but then she walked straight through the fountain and through the wall. That woman was as clear as day. She had on a big flowing skirt, the bottom of the dress was a gray and black and white plaid. The bodice was black with a white collar, and I remember seeing the glare of the sun on a broach at her neck, and

she had a big bun at the back of her head. I found out later it was Maria Estudillo.

There's an image in your photograph. It's just to the left of the window slightly behind the bedpost, you can see the edge of a woman's broad brimmed hat and a breast, and I believe you can actually see part of her right cheek. It's a very interesting photograph in that you actually caught a spirit and you were totally unaware of it.

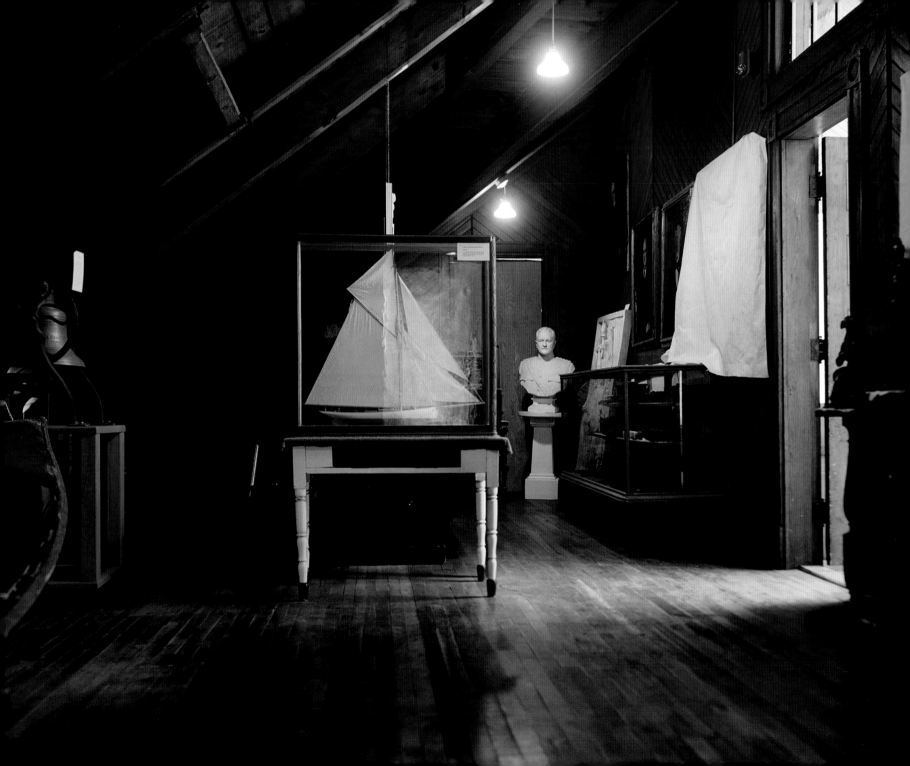

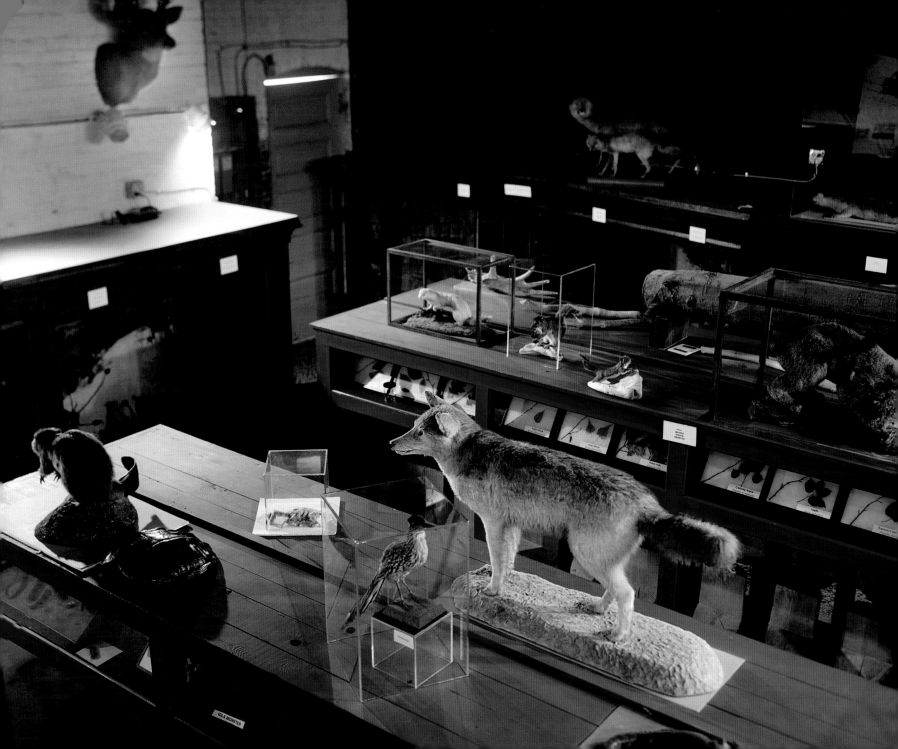

GILA MONSTER

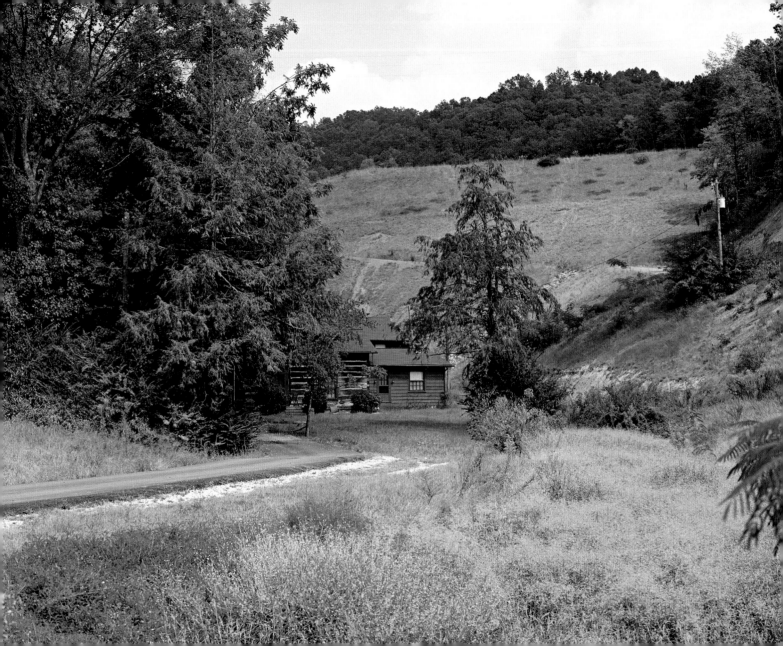

Log Cabin, Harlan, Kentucky

JAYNE

LIVED IN THE HOUSE FOR FIFTY-ONE YEARS

I ALWAYS HAD SUCH A SOFT FEELIN' FOR THE HOUSE. It had good vibes, friendly vibes. I never saw any illusions but I heard the most beautiful music. I couldn't identify it but it was classical music of some kind—prob'ly organ. I would hear it off and on, off and on, and I would just sit there and listen. I decided I'd better keep this to myself. After a time, I began to tell it to good friends. I'd say, "Okay, we're goin' to go in here and be real quiet." Sure 'nough, I had some friends hear it. I felt like I was saved. I thought, "It's not me!"

It was beautiful music. I heard it at diff'rent times but 'specially during the holidays, when company came over, and just a few people were left. Or sometimes, we'd hear it in the early morning, after breakfast. I declare I could hear it; it was so real. I wish you'd been there long 'nough to hear it yourself.

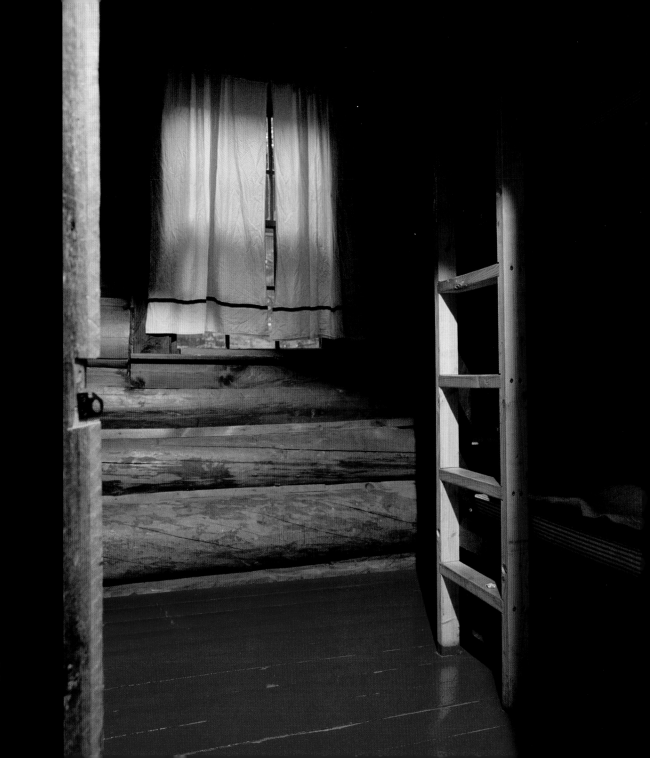

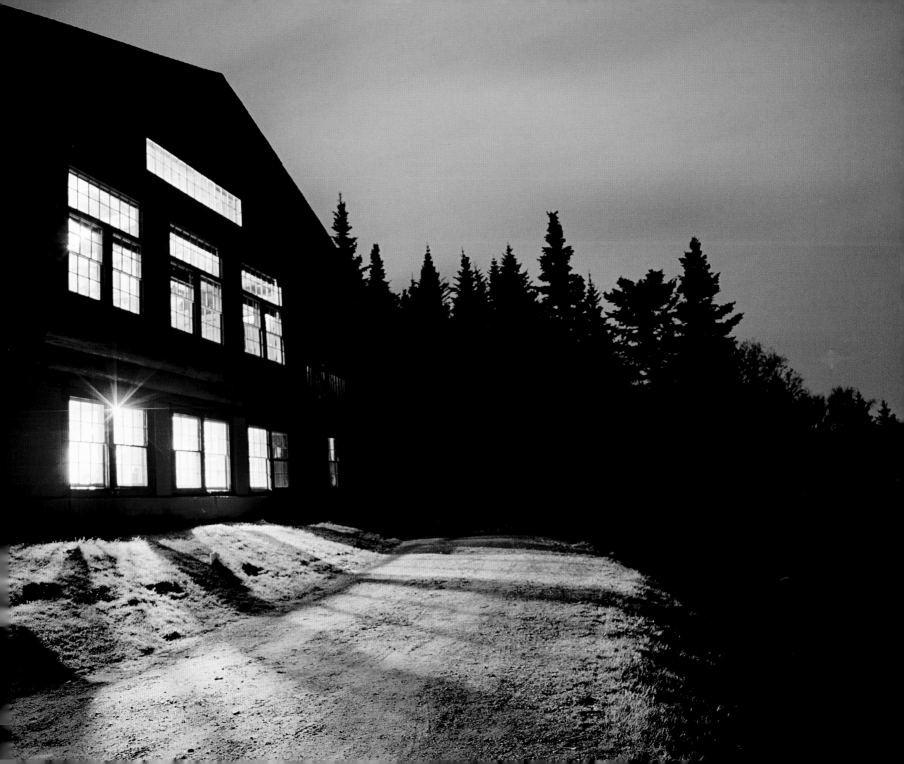

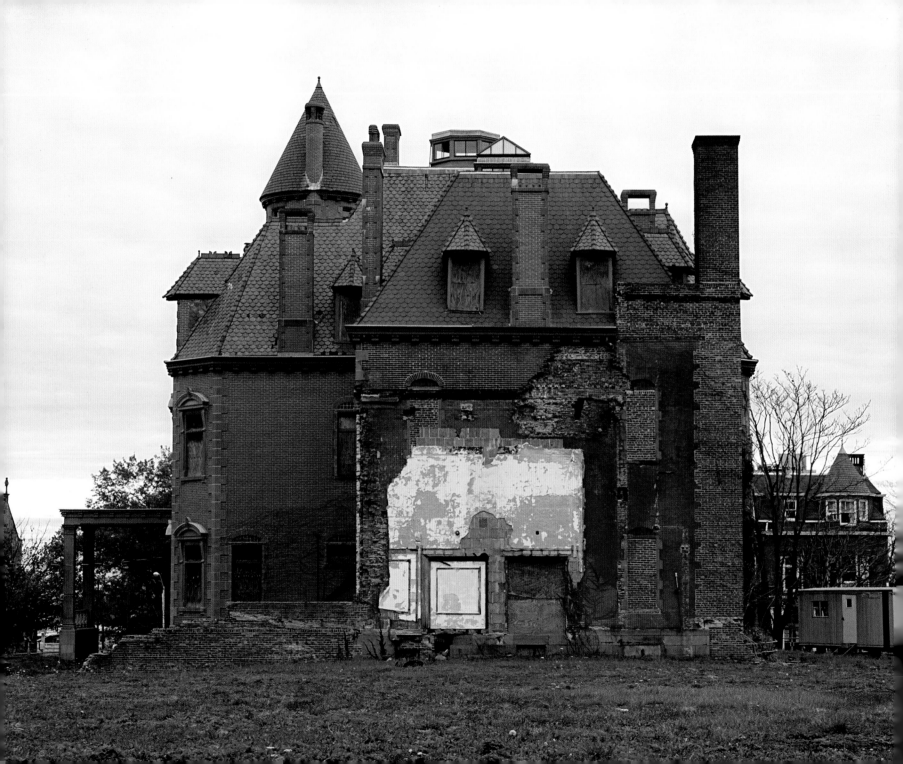

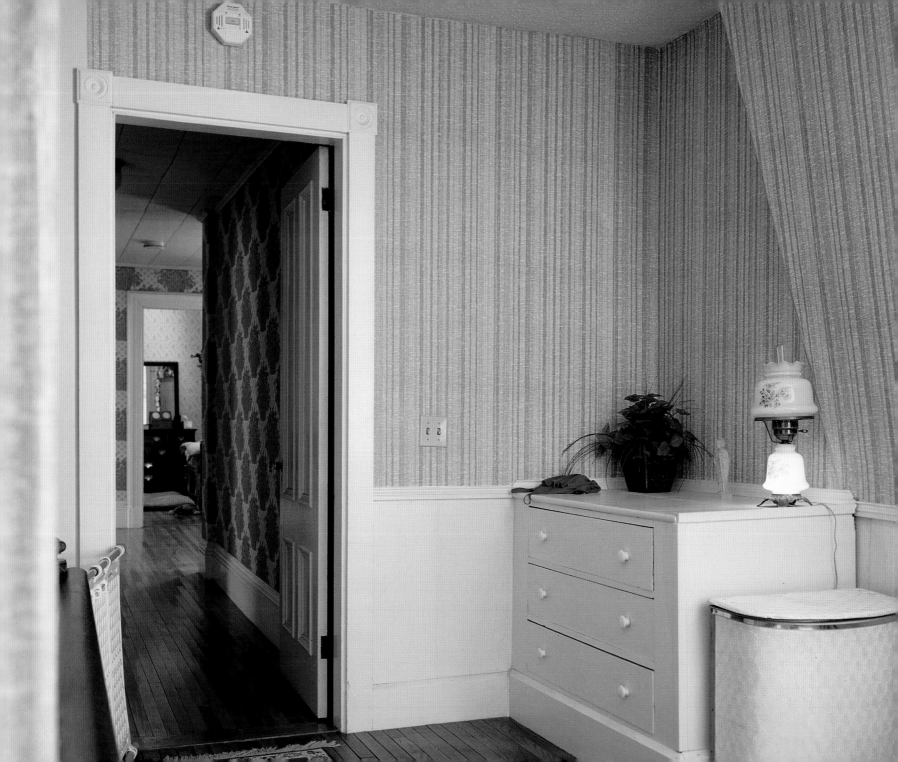

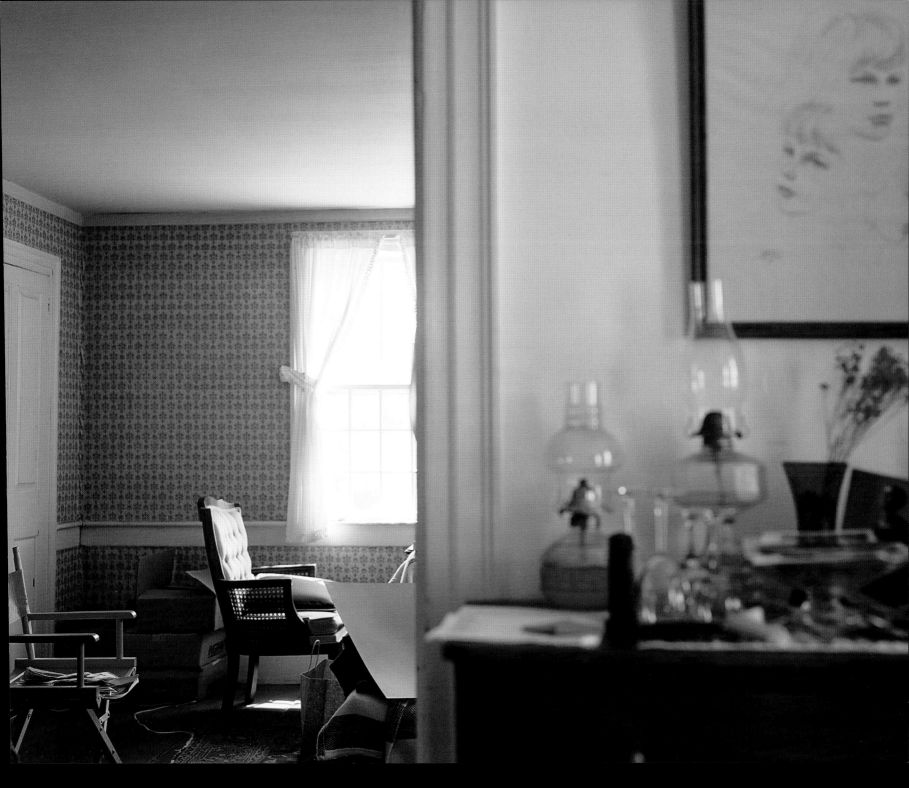

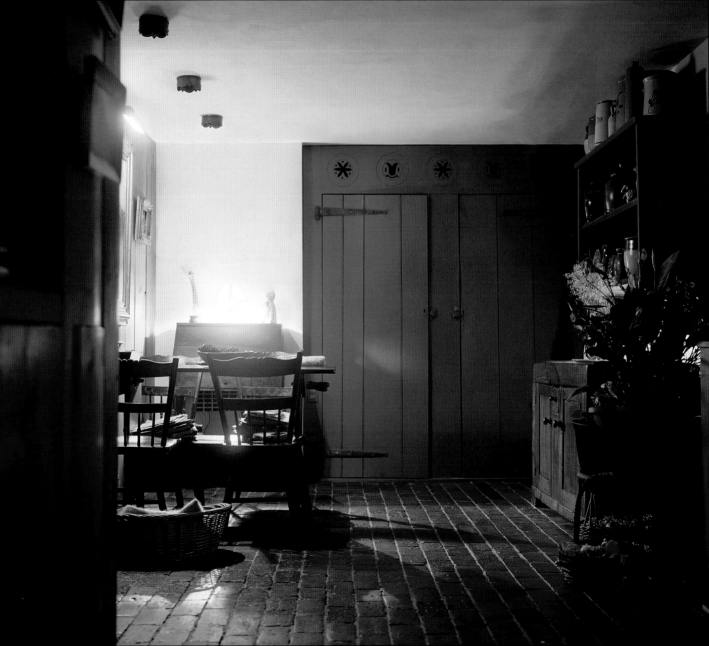

Private Residence, Somerset Hills, New Jersey

BERNICE, HOMEOWNER

EACH YEAR I HAVE A CHRISTMAS TEA WITH FRIENDS. On this particular year one of my guests was my former minister's wife whom I love and adore. She was standing around the dining room table along with a lot of other people. She had her cup and saucer in her hand, and she was drinking her tea. Without anything pushing it, her cup flew clear across the table. She was in total shock. It just flew! It was the most amazing thing. I was kind of embarrassed, to say the least. The rest of the group that couldn't fit in the dining room was in the kitchen, and an almost identical thing happened there. Someone's fork flew. I thought—I'm having a bad dream. And it didn't occur to me at the time that it was a ghost, although there have been ghosts recorded around this area.

Well, shortly thereafter my husband and I went on a short vacation. When we came home the lovely girl who was watching the animals and taking care of the house said, "Do you know that you have ghosts in this house?" And I said, "Really? How can you tell?" And she said, "There was so much conversation on the third floor. Voices, voices, voices, voices." I said, "Weren't you scared?" And she said, "No. There were just all of these voices talking on the third floor. I went up there, and I couldn't see anything, but I could hear them talking."

There are other houses in the area that have had strange things happen as well. I refuse to believe in ghosts and yet I must, because I saw it with my own eyes, I saw a cup fly across the table. It was . . . it was unbelievable. Both people were horrified. I didn't know how to explain it at that point in time. All I can think of is that because this house was a Revolutionary War commissary, many soldiers came and went here, many were killed here. So I don't really know who the

The other thing—oh gosh, this is important too! I walked into my kitchen one day and near the corner of my countertop I saw the blue uniform of a Revolutionary War solider. I put my hands over my eyes, and I said this isn't happening. But it was happening. And the next day my little helper came in, she's a Peruvian girl, very intelligent girl. And she said, "Do you know that in that corner of your countertop there's somebody in a blue uniform." I didn't tell her a thing. I almost fainted. I'll tell you it was scary. I said to her something inane like, "Oh, I've thought about it." [Laughs]

So yeah, I think houses have a certain something. Why does it happen? Why does the dog bark all of a sudden? Why does the cat go flying to the third floor? Why? I don't know. There's an awful lot we don't know about spiritual things, and where spirits live in houses. I am so opposed, if you will, to thinking that way. And yet, there's something in me that says how do you know? How do you know who lived here?

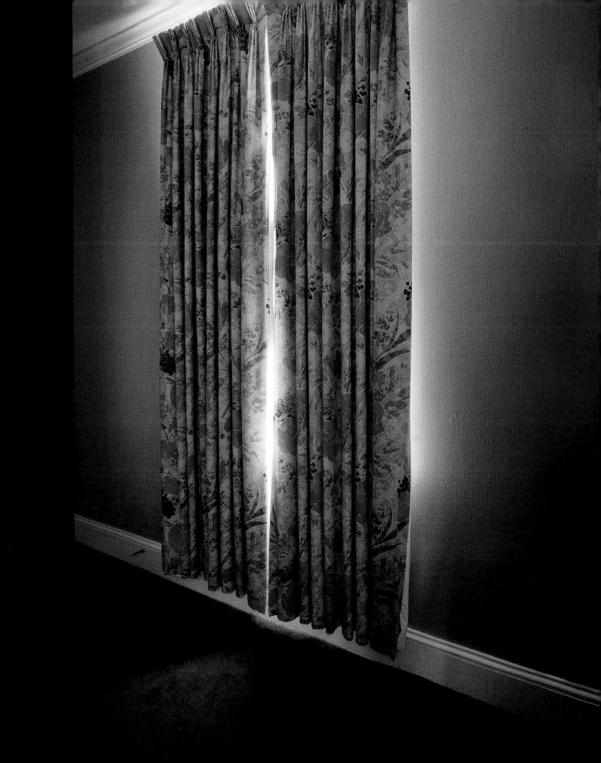

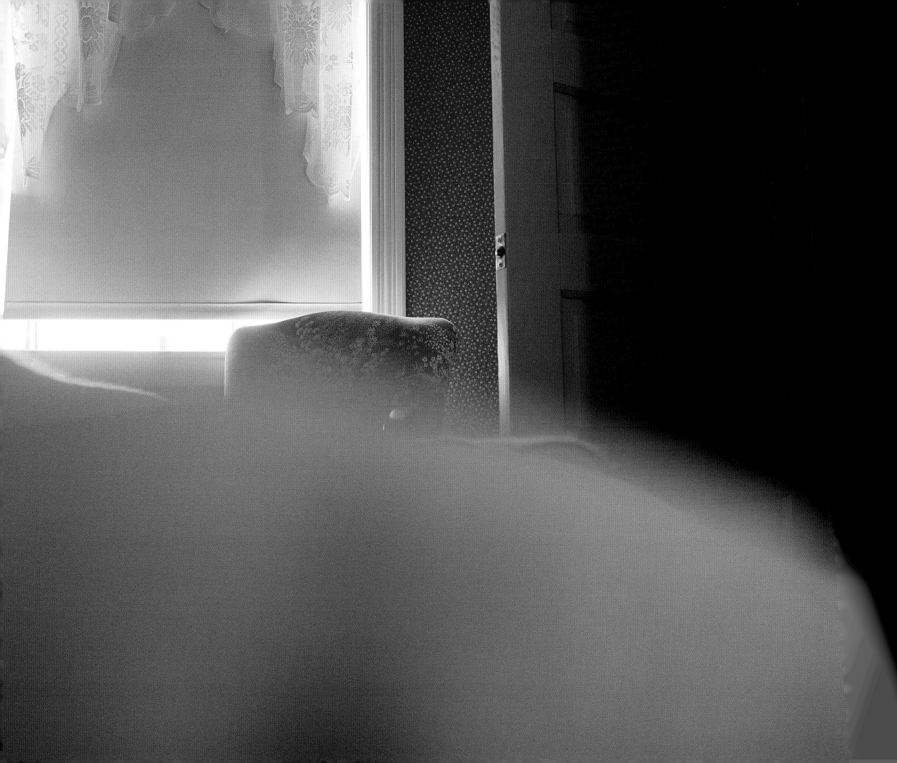

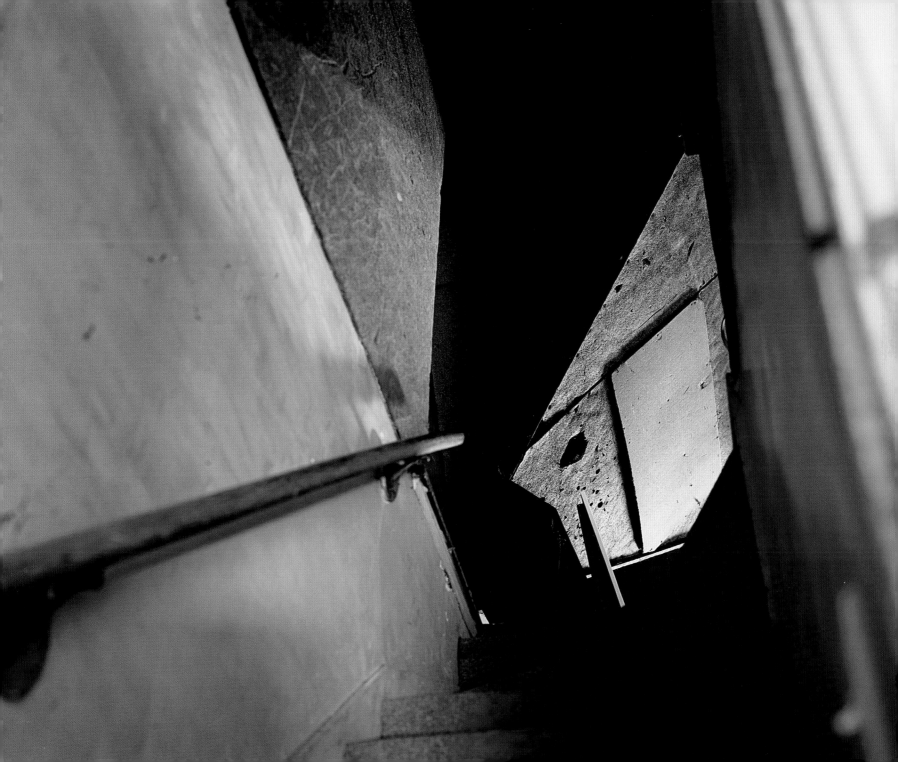

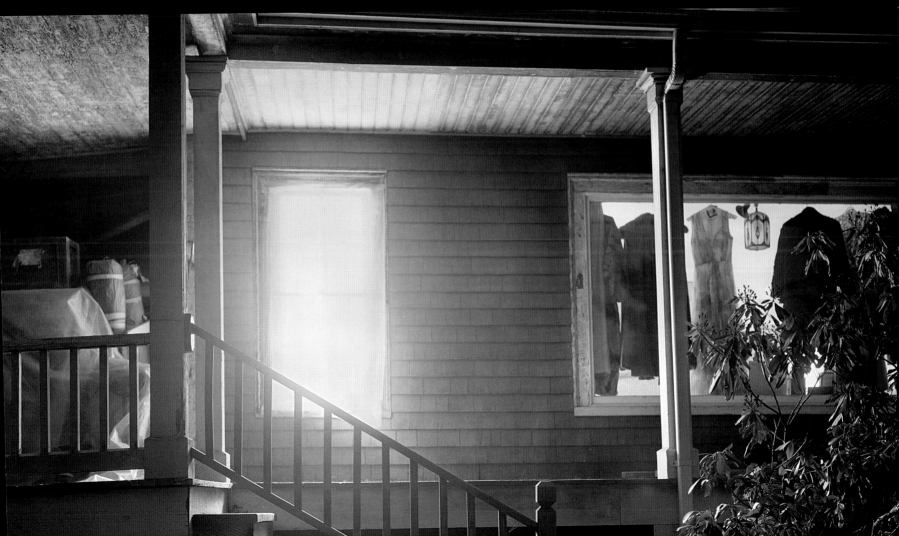

Private Residence No. 2, Skowhegan, Maine

DOM AND HIS WIFE, **LOUISE**,
HAVE LIVED IN THE HOUSE FOR THIRTY YEARS

DOM

MOST PEOPLE DON'T SEEM TO LIVE IN HOMES FOR FIFTEEN, TWENTY, TWENTY-FIVE YEARS. They're in a place for two years, and they may not get to experience whatever there is in the house. Not knowing the background of the house it really snuck up on us. We'd say, okay, somebody forgot to turn the TV off. Well, no one forgot to turn it off, it was already off when we went to bed, but when we came down the next morning the TV was on. Another time I walked into the bathroom and the tub was almost full of water. I walked down the hall and said to my wife, "Why are you filling the tub with water?" and she said, "What are you talking about?" I said, "The faucets are on full blast and the tub is almost

8-22-90
Glenn & Louise heard the faucet somewhere in home run & then shut off. Steve's sink was bad but I had previously used bathroom sink so I couldn't tell where it was done.

SATURDAY 11/10/01
2:10 afternoon
Louise & I + 3 dogs in family room working on floor squared with kitchen table put from table across floor

10-9-01
5:45 AM -
COULD HEAR DOG SWALLOWING & BREATHING IN UPSTAIRS BATHROOM
(NO DOGS IN THAT PART OF HOUSE)

3-22-98
came down woke up spoke in family room had stopped went to restart switch was in "OFF" position

Lab coat been ironed 2x's now. Check book missing for 1 week now.
8-8-93

2-10-90
12:30 P.M.
Sam Gene came in back door went upstairs - walked way down hall

Guest & threw new long mirror on floor at 4:30 am in the room Angie is now sleeping in. Nikki didn't do it and wasn't around. Window shutters were closed so the wind didn't do it either happened 6-8-93 Angie

8-16-91
DOGS & US IN STUDY - LOUD BANG IN THE ROOM, AS IF THING DROPPED AND HIT FLOOR

10-14-92
Wood stove in study: Blower was on - Don said he did not start fire this a.m. + did not turn on blower! I got up & came down at 9 am. Blower was on! + NO WOOD OR FIRE IN STOVE Louise

6-11-91
6-12-91
coming out of bathroom - perfume odor upstairs

5-7-90
Hot Water in tub turned on full?! Who did it?

1-7-02
PELLET STOVE IN DOM'S ROOM WAS SHUT OFF (SOMETHING WOULD SWITCH TO OFF) NOT DOM

JUNE 6 2004
8:00 Am Sunday came down stairs - cold water faucet on wide open in bathroom sink

8-17-02
LEFT CEILING FAN ON IN FAMILY ROOM - WAS OFF WHEN STEVE GOT HERE

4-29-90
5:55 a.m. FOOTSTEPS FROM BEDROOM DOOR - SLAM TO OTHER SIDE OF ROOM

3-16-90
Someone ran from our bedroom - down hall & down stairs
after 8 Am

3-16 or 15-90
Just closing my day around 7:15am when I (who I thought was mom) a person's footstep going past my door into the bathroom

9-7-06
1:26 AM
A JEWELRY BOX MUSIC CHIME PLAYED FOR 10 SECONDS

3-27-05
EASTER SUNDAY MORNING
7:45 AM -
FAUCET IN DOWNSTAIRS BATHROOM WAS ON

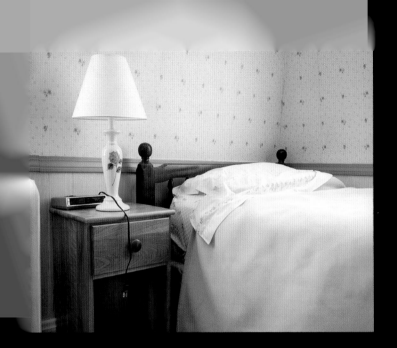

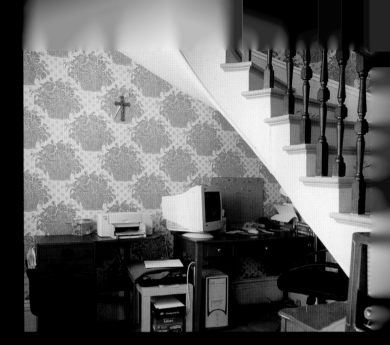

ull." Nobody turned it on. We were the only two people in the house. It was like a running joke. If our children needed to blame somebody, even if it had nothing to do with the ghost situation, they'd say, "The ghost did it!"

There were a lot of things, but we didn't put two and two together until we happened to talk to the original owner. He went on and on about the ghost, how terrible it was to him and how he was nervous and scared all the time. He put up crosses on the doors and once yelled, "I'm a rational man, but please leave

In the early 1990s we started to keep notes about the ghos happenings. [He begins reading the notes.] This happened to me or the 7th of September, 2006, 1:26 a.m. I'm a very light sleeper, anc it was a musical chime like you'd have on a jewelry box. It playec for ten seconds straight. Saturday, November 10, 2001: It soundec like somebody took a chair and dragged it across the kitchen floor We all heard it, but when we got into the kitchen the chairs were all where they belonged. This is one of our daughter Angie's notes from August of 1993. She used to work as a dentist technician anc

> **I had a few people tell me that you had to stand in the doorway and yell at the ghost to leave. I yelled, "Get out of my house! I don't want you here anymore, you're annoying my daughter—stop!"**

she said it had happened. On June 12, 1991, there was a very strong scent of perfume. I don't have a sense of smell so I wouldn't know. Louise said to me, "It's unbelievable how strong it is." This is from 1990: Slow footsteps from the bedroom door to the other side of the room. This was a Sunday—a lot of things seem to happen on Sundays. February 1990, 12:30 at night, someone came in the side door, closed the door, went up the stairs, walked up and down the hall, and then the sound disappeared. A lot of activity happens in the upstairs hallway.

LOUISE
THE GHOST WOULDN'T LEAVE OUR DAUGHTER ANGIE ALONE. It would shake her bed and she couldn't sleep. She had a mirror on her wall that Dom had put up for her. She walked out of her bedroom and it went crashing into a million pieces on the floor. To this day we don't know how it happened because he put it up so good. All of us were just wowed. Angie had so many problems with

the ghost it was like a poltergeist. I had a few people tell me that you had to stand in the doorway and yell at the ghost to leave. I yelled, "Get out of my house! I don't want you here anymore, you're annoying my daughter—stop!" I felt like a fool. My kids were around and they were watching me because they were still very young. Afterward, it didn't seem to bother her as much. There wasn't any more shaking of the bed. Someone died in Angie's bedroom where all the stuff kept on happening. We've been told that a man hung himself in the barn attic but we can't find it in print. A young boy also died on the property.

I was looking for my husband and I thought he was in the kitchen because I could see this big man with a white shirt moving around. I'm saying, "Dom, Dom" and I'm following something and then it's gone. He's in the other room saying, "What? What?" His mom was behind me with her jaw open. Another time, I was in the kitchen and I heard something fall over and I saw this white thing. I looked and thought, "What is it?" and then poof! It was gone.

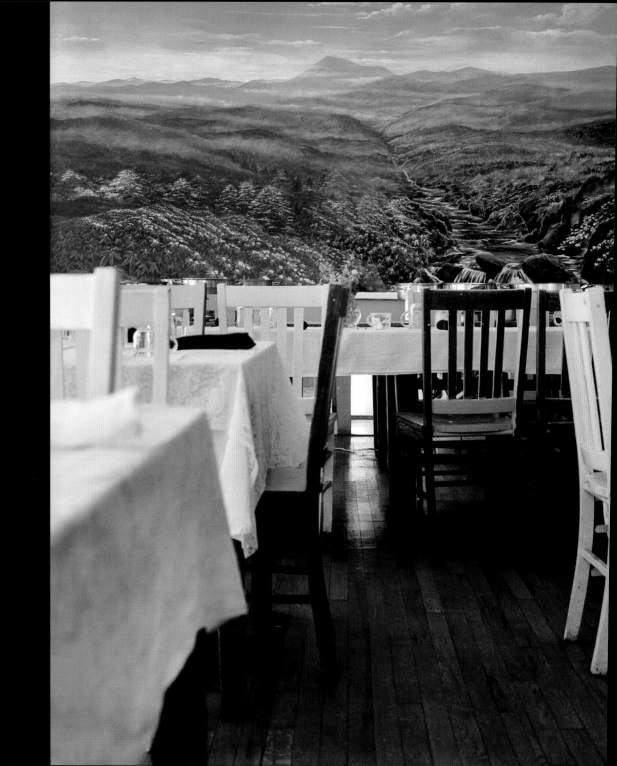

NANCY-LINN

FORMER RESIDENT AND INN OWNER, WHO LIVED THERE FOR TWELVE YEARS

WHILE WE HAD HEARD HORRENDOUS BANGS AND THUDS AT NIGHT THAT COULD NEVER BE ACCOUNTED FOR we never thought that it was past occupants of the house who were either trying to get our attention or to move us out. In May 1994 we realized we were not alone in the house. My friend Jane was visiting and I saw what I thought was my friend, at the buffet, looking at a Homer Winslow print—so it was only her back. I said, "Good morning" and she said, "Good morning back." About forty-five minutes later, Jane arrived in the kitchen, and my husband said, "Good morning—when did you get up?" Jane answered, just about ten minutes ago. I said, "Oh yeah, how come you were looking at the Homer Winslow print about forty-five minutes earlier?" Jane was shocked and literally wanted to leave.

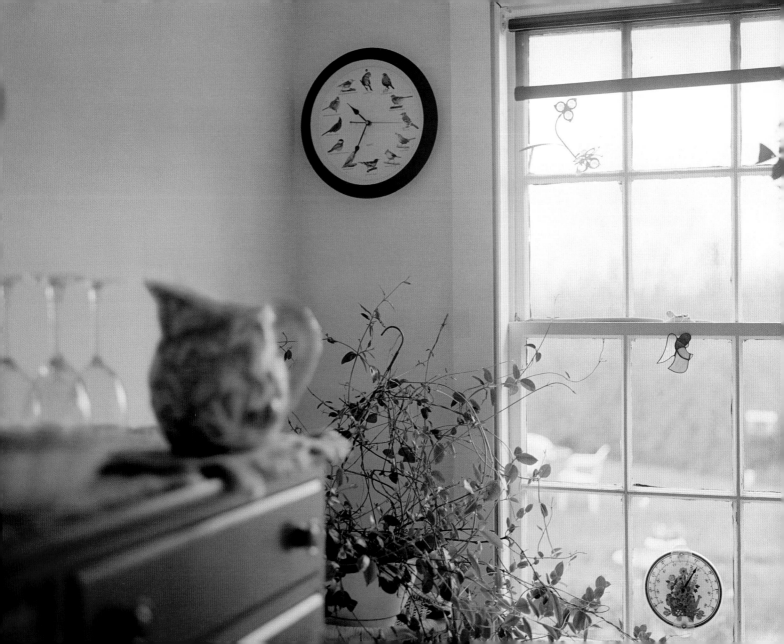

He asked, "Have you met Connie yet?"
My answer was, "If you mean the spirit then yes."

Not long after that, I needed to speak with the man we had purchased the house from. He asked, "Have you met Connie yet?" My answer was, "If you mean the spirit then yes." He immediately said, "Just tell Connie that she is welcome and that you are going to take very good care of the house." Sometime around July of that year our guests were breakfasting on the sun porch, when one looked up and asked, "Do you have ghosts?" to which I responded, "Why do you ask?" She said, "I ask because they were in my room last night." She then went on to explain that it was a couple, they were in period dress and merely stood at the foot of the bed watching her. We have mysterious disappearances of items—never to be found again. We have found small puddles of water where water should not be.

I truly believe one must be very sensitive to their surroundings to feel and understand what is happening. Many guests report the music—and it is always extremely loud. A few have reported pulling the plugs so that the radio will not go on in the middle of the night. I believe one must be very sensitive to their surroundings to feel and understand what is happening. I could not deny it, I just don't bring it up as a topic of conversation because Hollywood has us all believing that ghosts are almost like ghouls and something to be afraid of. Our spirits seem to appreciate that I always acknowledged their existence, and we have all learned to live together in harmony.

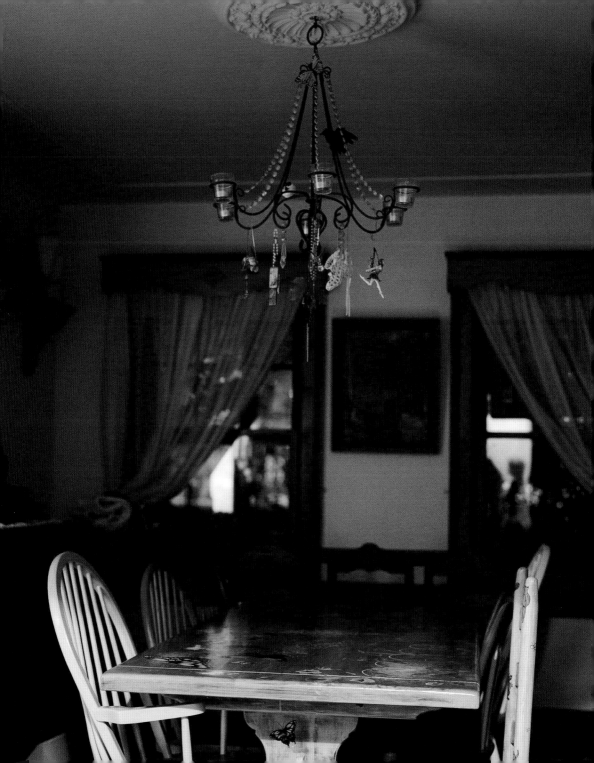

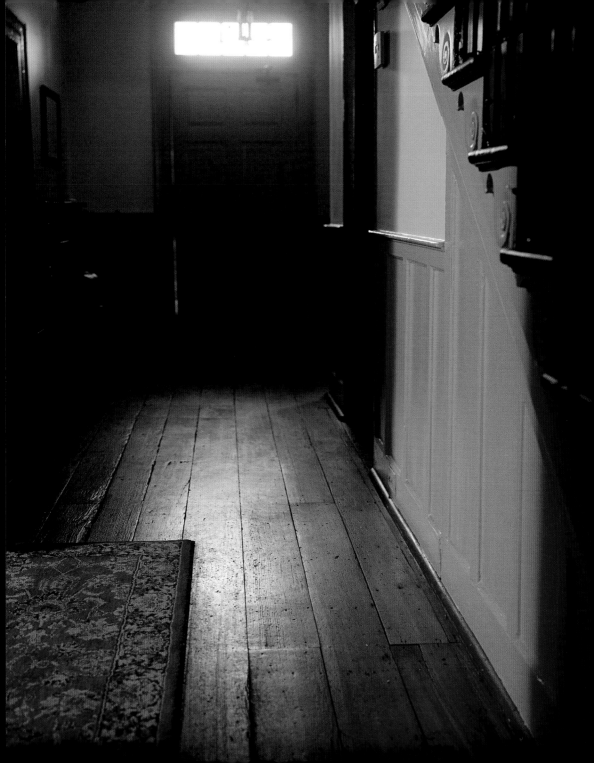

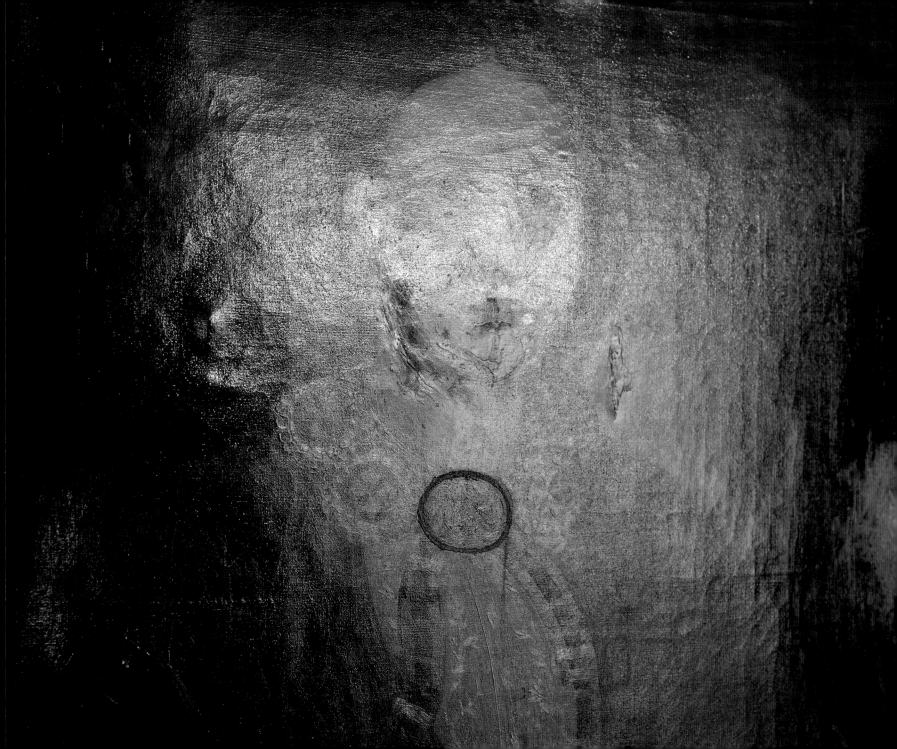

Alice's Grave, Pawleys Island, South Carolina

MARY, LOCAL RESIDENT

ALICE'S FAMILY WAS VERY PROMINENT IN THIS AREA. When she had her coming-out party, her brother who was studying to be a doctor brought a friend who was working his way through school. She met and fell in love with this friend of her brother's. They got engaged, but because his social standing was so far below her family's, she was forbidden to see the young man again. So she hid the ring around her neck. Later she caught malaria. Her family was in Europe at the time, so her brother came from Charleston to take care of her. But during the course of her delirium her brother was sponging her down in order to lower her fever and came across the necklace with the ring on it. He ripped it off her neck and threw it down the stairwell. She reduced her strength by going up and down the stairwell looking for her ring. She

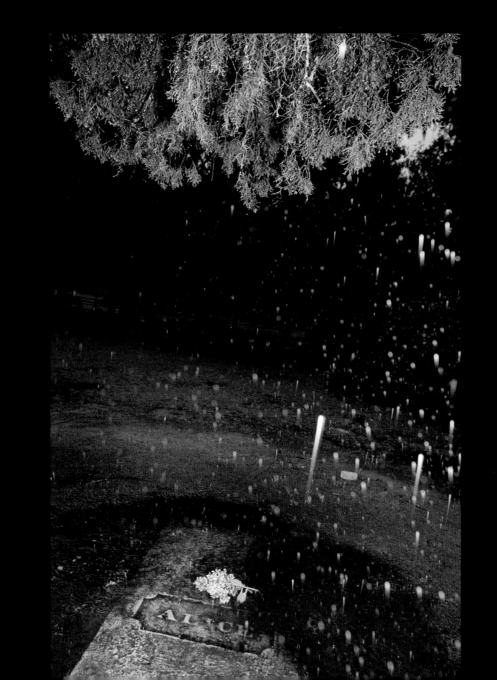

They say if you put a ring on her tombstone
and walk around backward you'll see her ghost rise up
and she will turn the ring, to see if it's her missing ring.

eventually died from this disease. She had disgraced her family, so they buried her with just her first name.

Her ghost has been seen by some very prominent professors and people that you would not scoff at, around the Hermitage, the house where Alice died, and here as well. They say if you put a ring on her tombstone and walk around backward you'll see her ghost rise up and she will turn the ring, to see if it's her missing ring. And sometimes they say you can feel it as she turns the ring on your hands. You can see the well-worn path around her grave.

My parents' house is on a direct path as the crow flies between here and the Hermitage. And we've seen her ghost coming

through the yard. Just telling the story I get chill bumps from the memory of seeing her. The night my mother and I saw her ghost, our family dog ran under the couch and refused to come out for two days. She looked like what you would expect a ghost to look like. Long white dress, long blond hair, or the appearance of long blond hair cause you couldn't really see color of any kind. She was a mist, but she had definite features. You could distinguish that it was a woman in formal attire and she floated through the yard.

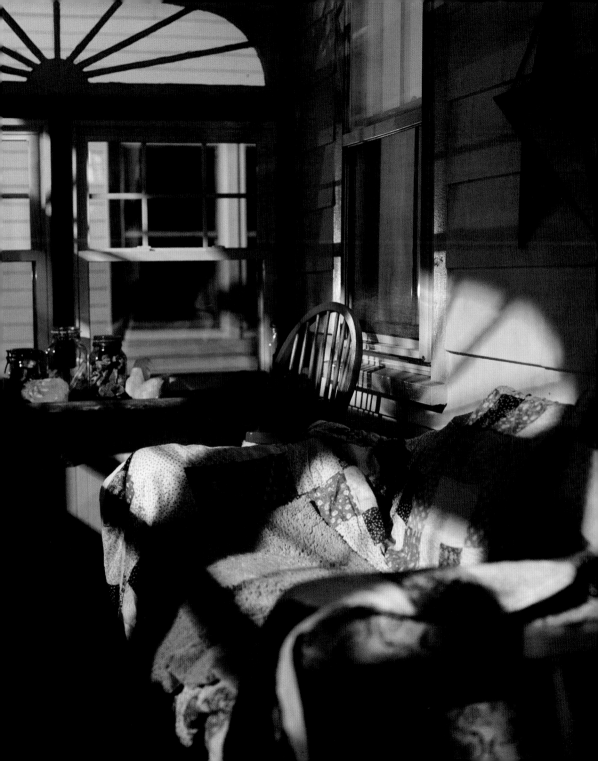

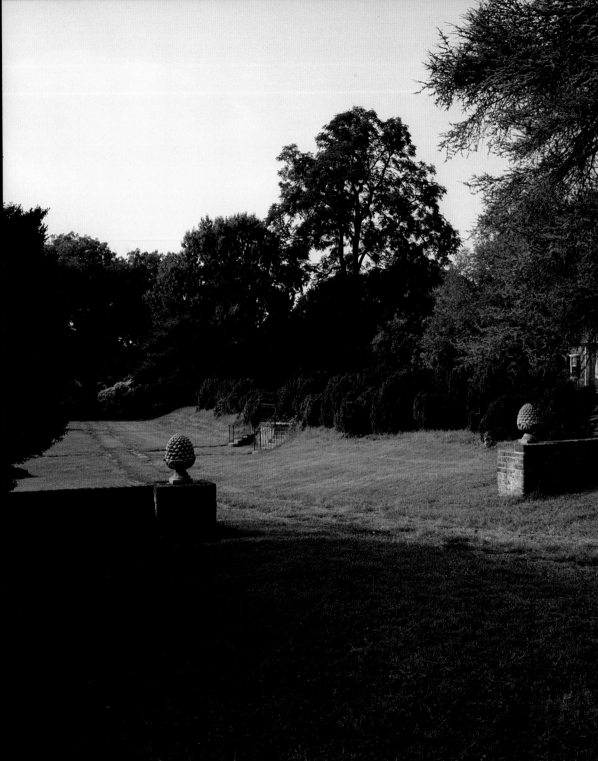

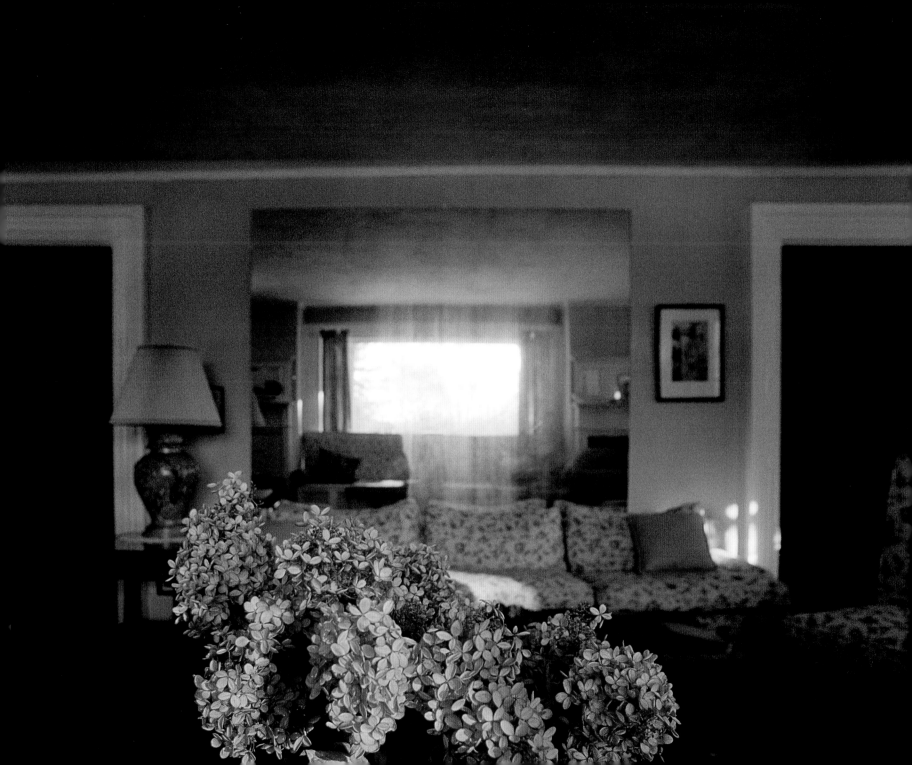

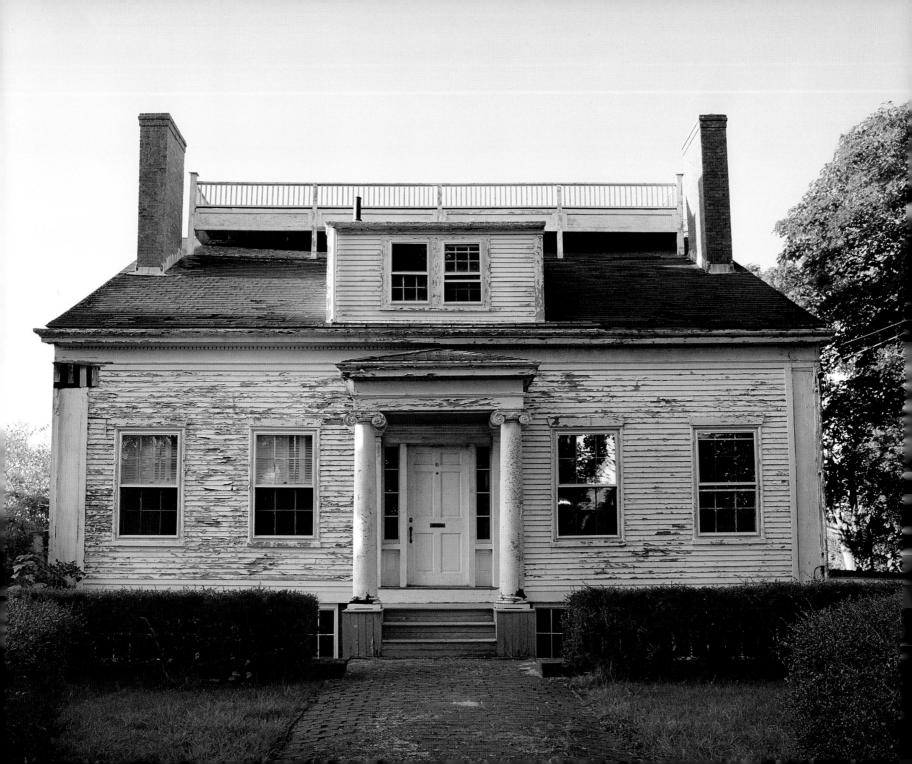

MY HUSBAND WAS NAPPING IN THE SPARE BEDROOM, WHEN HE WOKE TO THE DISTINCT FEELING THAT AN ENERGY OR SPIRIT OF SOME KIND WAS TRYING TO PASS THROUGH OR ENTER HIS BODY. He felt that it came up from the basement through the closet. He was terrified.

I also felt uncomfortable in the house, and I put off moving in for a whole week. Soon after I moved in I heard footsteps downstairs, but I didn't investigate. Another night, toward the end of my stay, I was sitting in the kitchen with my back to the corner of the room, and I heard the sound of something brush against the wall behind me, but there was nothing there. Later, after hearing everyone else's stories, I dreamt that the name of the ghost was Violette Laughlin; her

I woke up and the bed lifted and moved three inches from the wall.
There was a loud thump. I was shocked and shook the bed
to see if my sudden jerk waking may have caused the bed to move,
but it was impossible to make the bed lift in this manner.

name was revealed to me by two fingers that traced the initials V and the L onto the bed sheets.

HEIDI, TENANT

I WAS LYING AWAKE AT 3 A.M., as I often did that summer, and I felt something like light footsteps move across my bed. The next morning, my roommate said that around the same time she woke up or dreamt about a presence in her room. The house itself is very strange and uncomfortable.

BRIAN, TENANT

THE FIRST THING I NOTICED IS THAT WHEN I WOULD SIT ON THE BED AT NIGHT READING THERE WOULD BE NO BREEZE. When I laid down on the bed a breeze would glide across my body. I would sit up and no breeze, lay down and the same breeze would blow across my body. I tested this several times. During the day and night, the bottom corner of the bed vibrated.

I was dreaming that I was standing arguing with my brother. He turned into a white-haired woman straddling me. I was lying on my back and she held my wrists. Surprised it was not my brother, I pulled her closer to me, in order to see her face. She had white hair, a thin, smooth, chalk-white face, and was at least sixty-five years old. Her eyes were smoked over from cataracts, and two men in black suits arrived. There was one on each side of her, and they pulled her away from me. This was the end of my dream. I woke up and the bed lifted and moved three inches from the wall. There was a loud thump. I was shocked and shook the bed to see if my sudden jerk waking may have caused the bed to move, but it was impossible to make the bed lift in this manner.

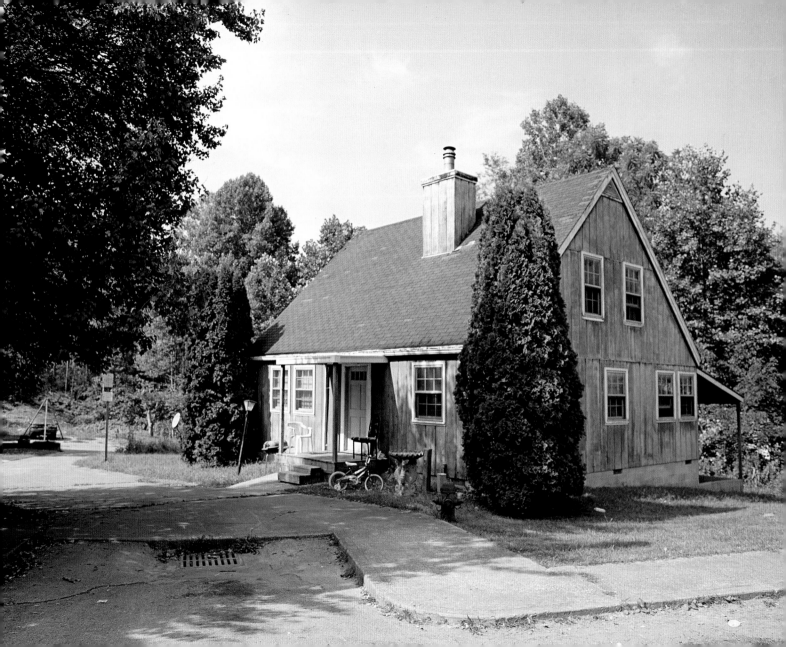

Private Residence, Cumberland, Kentucky

KAMI
LIVED IN THE HOUSE WITH HER HUSBAND AND
DAUGHTER FOR THREE YEARS AT THE TIME OF
THIS INTERVIEW. HER HUSBAND'S FAMILY BUILT
THE HOUSE, AND NO ONE OUTSIDE THE FAMILY
HAD EVER LIVED THERE

WHEN MY IN-LAWS WERE STILL ALIVE AND LIVING IN THIS HOUSE, MY
FATHER-IN-LAW SAID THAT WHEN HIS WIFE WAS AT WORK THE GHOST OF HIS
MOTHER-IN-LAW WOULD START MESSING WITH HIM. My husband and his brother
had a robot. My father-in-law said that the robot went off by itself—the arms started moving and
everything. He didn't get along with his mother-in-law at all. He told her that if she stayed upstairs,
he would stay downstairs, and he swears that she stayed upstairs. Although he was always scared

ally ended up falling back to sleep.

Another time, my husband and I were asleep in bed and we heard music playing upstairs. We were the only people in the house. My husband's grandmother liked gospel music but it wasn't gospel and it wasn't rock 'n' roll. It was calm, soothing meditation music. Another time my husband and I were home alone, and I heard a glass break when I woke up in the morning. As soon as I came out of my bedroom door I saw the broken sconce on the wall. The candle had lit on its own in the middle of the night, and it had burned so long that it broke the glass.

We have a Christmas carousel that belonged to my mother-in-law. It was arranged on the table by our front door, and it wasn't plugged in. We were sitting in the living room watching TV with some company and it started playing. It went in intervals of three. It played three times and then it stopped, and then it started playing again three times and then stopped. My mother-in-law bought a Barbie car for my daughter about five years ago. She got it at a church sale. It was a remote-control car, but she never had the remote control, and she didn't have batteries in it. One day her car just started driving all over the place, the headlights lit up and everything. It's done that two or three times.

There have been little things. Some stuff would be missing and I'd look where I thought it was, but it wouldn't be there. All o

One time my husband was home while I was at work,
and he heard some women giggling and calling his name.

Sometimes we hear people walking around upstairs. One time my husband was home while I was at work, and he heard some women giggling and calling his name. His name is Anthony, but he goes by Tony, and they called him Tony. They were hollering, "Tony, Tony." He wasn't about to go upstairs and check. The women continued to giggle. He believes that it was his mother and his grandmother because it sounded like them.

When my husband was sick in the hospital, he was lying in bed and the ghost of his mom was sitting at the foot of the bed. She was talking to him and he was talking back to her, and they were laughing. But when she was talking he couldn't hear anything she said, he could just read her lips. I asked him what she looked like, and he said that she was young and was wearing a white gown. I later found a graduation picture of his mother and he said that the dress was the one she wore in the hospital.

I had a similar experience. I don't know if it was a dream or reality. I know I was asleep, but the dream, or whatever it was, was so real, it was really going on. My mother-in-law was standing by the foot of the steps, and she was talking to me but I couldn't hear her, I could only read her lips. There was a baby asleep on the sofa, a little boy, lying in his diaper and a onesie. I can't have any more kids, and my mother-in-law always wanted my husband and me to have a baby of our own. She didn't have any grandsons so she wanted us to have the first boy. In that dream, or whatever it was, she was talking to me and telling me about this baby, and I couldn't understand where the baby came from because I knew it wasn't mine. And to this day, I don't understand what it meant, or why she came to me.

MIA, SIX YEARS OLD
ONE TIME I WAS PLAYING WITH MY CONVERTIBLE AND THE LIGHTS JUST POPPED ON and it drove everywhere. Somehow the door opened and it went outside, and I had to chase it. I was playing upstairs in my room and it did the same thing.

One time I was sleeping on my bunk bed and my granny came. I felt her and saw her. She looked prettier. She had short hair that was dyed brown, and there were curls. She was wearing a white shirt with long sleeves and a white skirt, high heels, and pretty sparkly earrings.

One time when I was sitting on the top bunk, and I was praying to the Lord, I saw my granny walk in the door and she scared me. I had to go down to Mommy and I cried and I couldn't go to sleep.

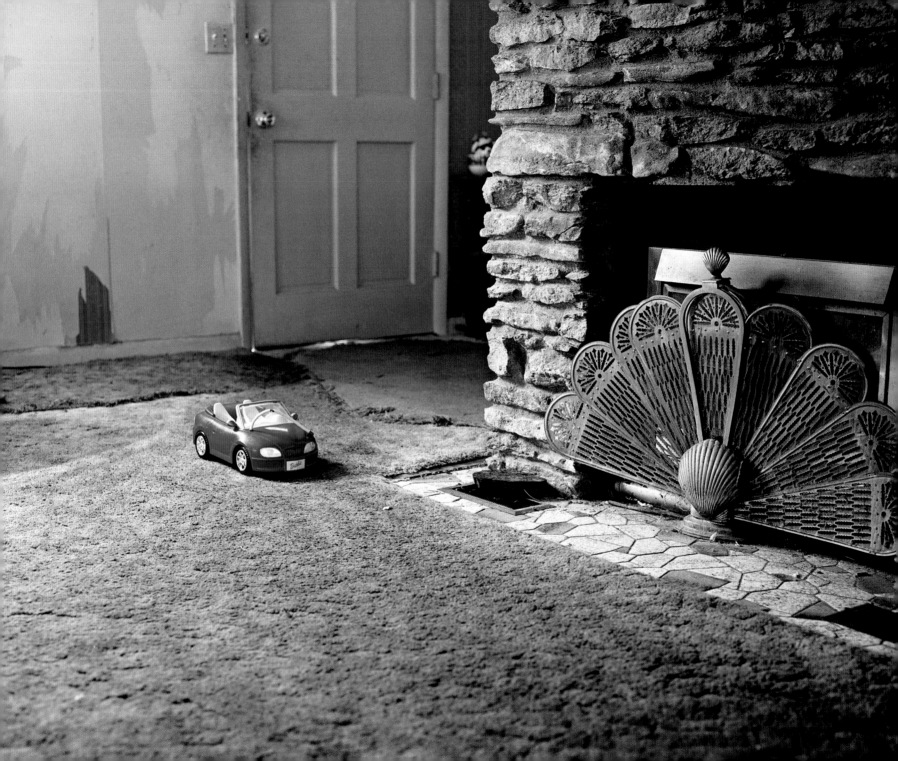

Private Residence, Dobbs Ferry, New York

DENISE
HAS LIVED IN THE HOUSE SINCE SHE WAS A TEENAGER,
FIRST WITH HER MOTHER AND SISTER,
NOW WITH HER HUSBAND

FROM THE MOMENT WE MOVED INTO THIS HOUSE WE FELT COMFORTABLE. Sometimes when you move into a place you need to get used to it and adjust to it, but we felt at home right away. There were little things about the house. My sister and I were pre-teen, and we lived with just my mother. Sometimes we'd go to bed at night and leave the TV running, we'd wake up and the TV would be off but no one had turned it off for us. We didn't think about these things until it became common: the TV and lights were always turned off, we forgot to shut the door and someone shut it for us. We began to test this and discovered that if we intentionally left a light on, the next morning it was turned off. Surprisingly, none of it ever felt uncomfortable or unsettling; it was more of a comfort. It was like caretakers in the house. It's like when your

husband's away and the house suddenly seems a little creepy. Well, we never felt that here. We never felt like we were alone.

One night when I was a teenager I woke up, and I thought there was someone in my room. I looked around and there was someone at the foot of my bed. I could see him from the knees up and he had on a blue and white flannel checkered shirt. I tried really hard to focus, because it was 6:00 in the morning and I was still half asleep. Everything was clear: he had very blond hair parted almost in the center, he wore faded blue jeans, but I couldn't see his face. I would say he had no face because it was almost as if I could see through it. I tried to figure out what it was. I obviously didn't recognize the person, but it was like okay and I relaxed and went back to sleep. When I woke up, I remembered what happened and it was a little creepy, because things had happened in the house but we didn't see them happen. We didn't see the light go off, we didn't watch a stranger go past, or feel a breeze, so it was the house. Now there was a young man. I told my mother about it and she laughed and it became a joke—"Casper the Friendly Ghost."

A couple of weeks later on a Sunday night my mom woke up and felt somebody in bed beside her. At first she assumed it was my sister, who would sometimes climb in bed and sleep with her. But when she turned and opened her eyes there was no one there. That wouldn't have been too bad except that she could hear someone breathing, and it disturbed her a great deal. She tried to sort out what was happening to her. Once she realized the whole concept, she felt okay with it and went back to sleep. I thought that was funny because that's what happened to me. We had such an unusual experience, which would normally frighten you and make you jump out of bed and say I'm not going to sleep the rest of the night. But we were

actually comfortable with it and went back to sleep. It didn't bother us until the next day when we had time to think about it.

The next Sunday my mother woke up in the middle of the night again, and she felt like somebody was in the room. She looked near her dresser, and there was a man with a red and black flannel shirt. It definitely wasn't the same ghost that I had seen, because I saw either a young man or a boy, and she saw a husky man with broad shoulders. He had a beard or a mustache, but she couldn't see his face no matter how hard she focused. She came to terms with what she had seen and went back to sleep.

We were talking about the ghost in the kitchen one day and my sister came in and said, "Oh, you mean the ghost? I see him sometimes too." A lot of times her friends would come and knock on her basement window at night. She would see a blond boy with a flannel shirt, and the first time she let her friends in she asked where the other kid was, but they had no idea what she was talking about. None of the kids who came to the window saw the ghost, but my sister saw him through the window a couple of times. This was back in the late '70s and it was very interesting because my sister and I weren't very close, so we didn't talk about much. Yet she described the same vision right down to what he was wearing, his blond hair and that she couldn't make out his face.

I have a neighbor who comes over on occasion and is uncomfortable in the house. He's a bit of a psychic, and one day he told me he didn't like going upstairs. He said, "There's a boy in your room and sometimes he's sitting there when I walk by." I said, "Can you describe him?" He replied, "He has blond hair and he's wearing a blue and white flannel shirt." I said, "Oh wow, I guess he's still around." I had only seen him once so long ago, but it seems whoever was here is still here.

Surprisingly, none of it ever felt uncomfortable or unsettling; it was more of a comfort. It was like caretakers in the house. It's like when your husband's away and the house suddenly seems a little creepy. Well, we never felt that here. We never felt like we were alone.

Seven years ago I began babysitting in the house. One little girl was very colicky, she cried a lot, and it was very intense and stressful. One day, I was pacing back and forth, trying to comfort her. I noticed someone was standing at the top of the stairs, but when I looked up they were gone. I thought maybe it was some sort of spirit or energy attached to the child because she was in a lot of distress. He was wearing brown lace-up shoes and dark brown slacks. This was a very different feel from the other ghosts; it was more like somebody from the '30s or '40s. I could not see beyond his knees because of the way the stairs were, and when I looked up he was gone.

I wouldn't be a bit surprised if the more recent ghost was the previous owner of the house. They were Charles and Bridgette McLaughlin, a lovely couple. I knew them from when I was young, because before we bought this house we rented a house across the street. They always wanted us to come and visit. They always had tea and biscuits for us. Maybe he's looking after these kids, because he never had any of his own. He loved this house, he did a lot of work to the house and he put a lot of himself into it. I don't know for sure, I've never seen his face, I've never seen more than his feet, but that would be my guess.

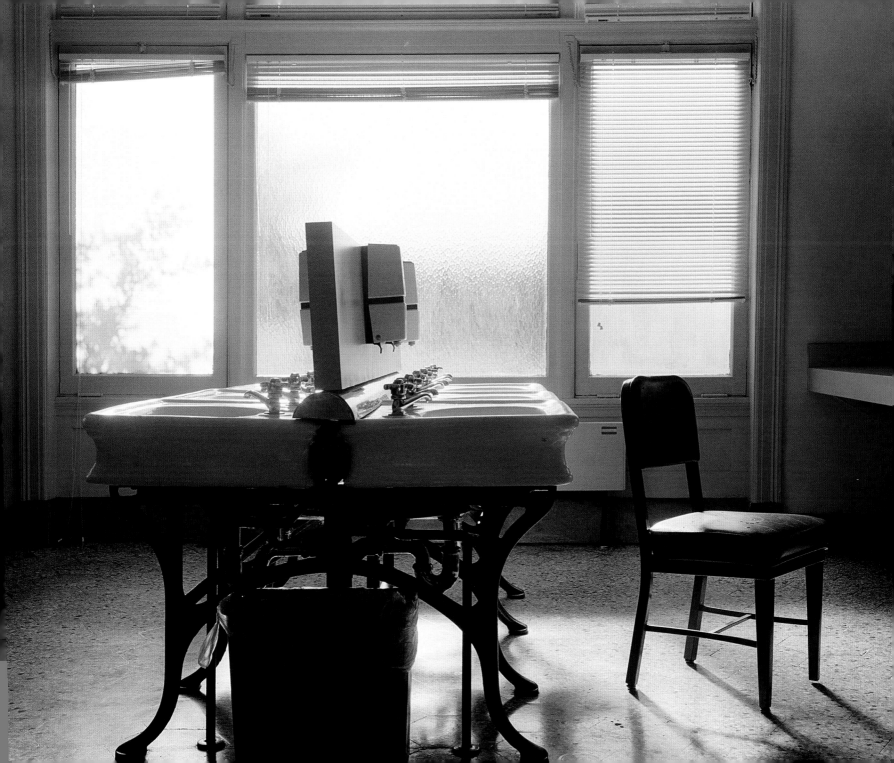

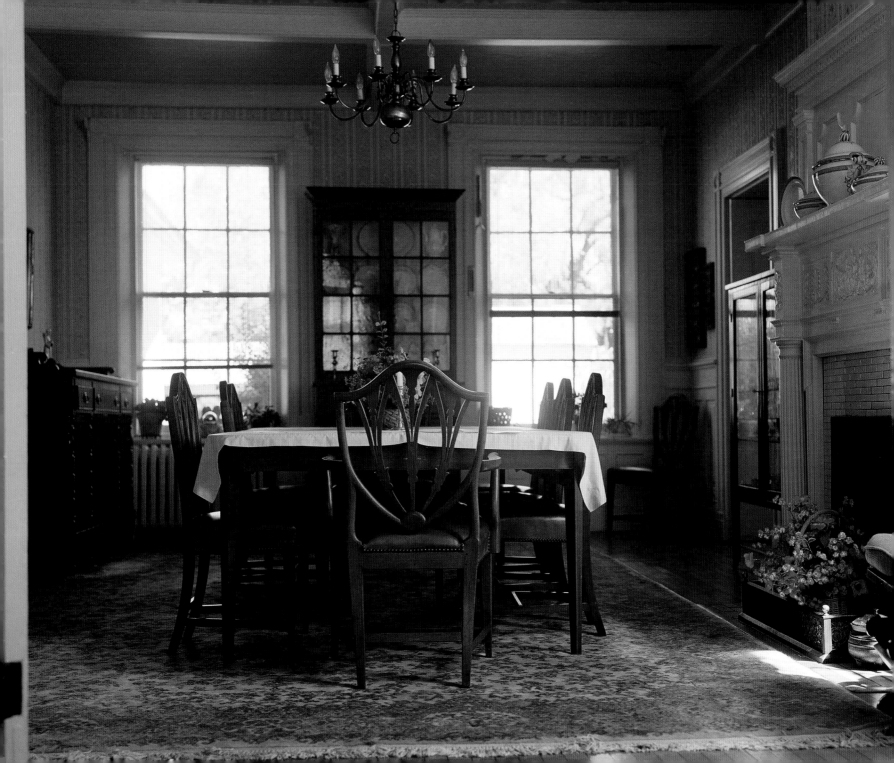

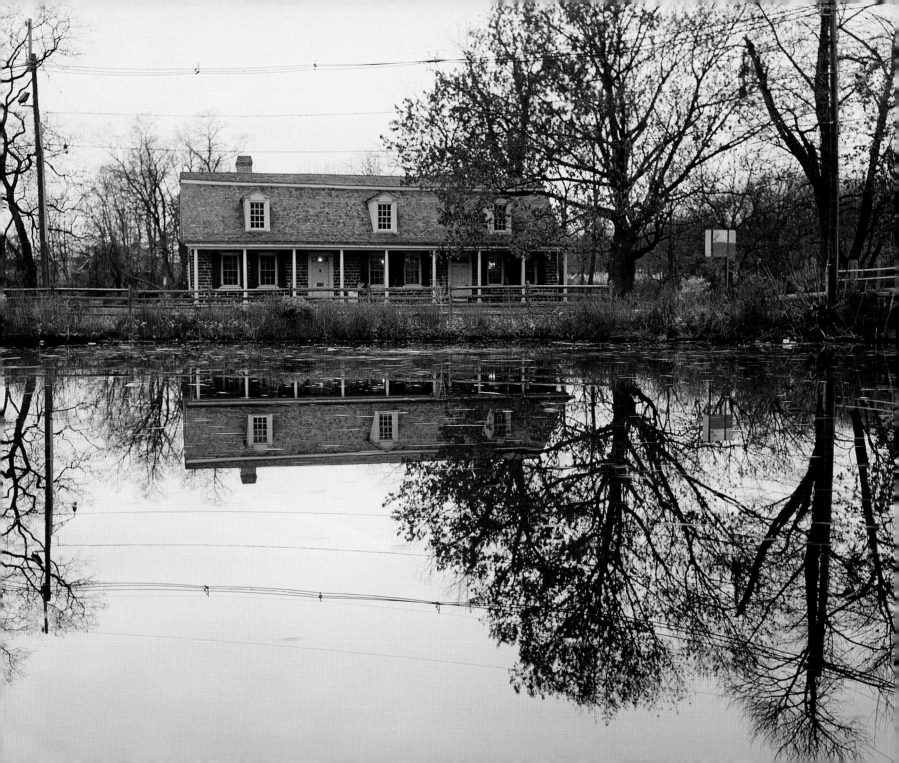

Merchant's House Museum, New York, New York

ANTHONY
A VOLUNTEER AT THE HOUSE SINCE 1981

MY FAVORITE PERSONAL EXPERIENCE OCCURRED ON SUNDAY, OCTOBER 8, 1989. IT WAS A BEAUTIFUL WARM DAY, and we had the windows open to let the fresh air in. I was on duty as the site manager and at 5:00 p.m. I was the only person left in the house. In those days I was really creeped to be there alone. I had a habit of either talking out loud or whistling because the sounds would break the mood. I started going room to room, closing the windows, closing and bolting the shutters, turning off the lights, and shutting the doors. I reached the second floor and I walked past the back bedroom and glanced inside; the windows were open and the lights were on. I walked to the front bedroom and closed that up first and then I walked through the connecting passage to the back bedroom. I distinctly remember saying out loud, "There's just this one last room and then I can leave." I opened the door and just froze in my tracks

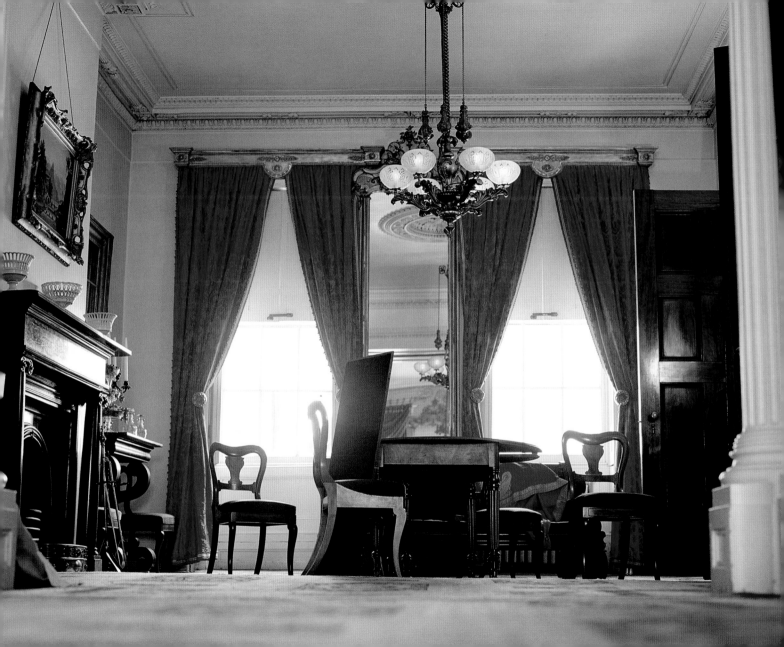

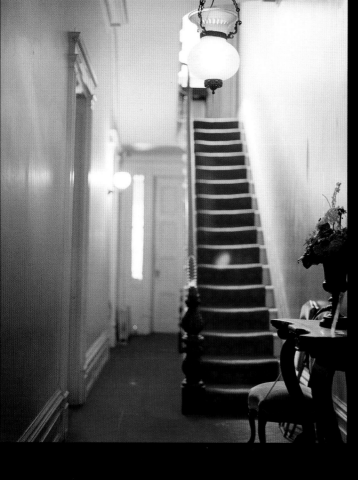

because I had just glanced in the room and now the windows were shut, the shutters were closed and bolted, the lights were turned off, and the door to the hallway was also shut. I was really creeped and I remember saying a quick, "Thanks Gertrude," and then I was out of the house in seconds. I was supposed to come in the next day but I called in sick.

Gertrude is our patron saint of the house. She was the youngest daughter of the Tredwells and she lived her entire life in the house. She was born there in 1840, grew up in the house, and family legend has it that she fell in love with a man that her family felt was unsuitable and they told her she could not marry him. She told them, "If I can't marry him then I will marry no one." The verifiable part of the story is that she did indeed marry no one. Three of her other sisters also did not marry and they lived in the house together for a long time. Gertrude was left alone in the house with a nephew and caretaker for the last twenty-six years of her life. By this point the family fortune had given out. She was a genteel lady so she was not raised to earn a livelihood; she was expected to marry a well-to-do husband. All of us feel for Gertrude. How sad it must have been for her borrowing against the house in order to have enough money to scrape by. And yet she refused to leave the house. She could have sold the house but she didn't and according to family legend she "kept it as Papa wanted." She died at ninety-three years old in an upstairs bedroom. The house was in foreclosure and it would have been torn down or converted into a commercial building, but a distant cousin realized what a tragedy this would be and at the eleventh hour he bought the house lock, stock, and barrel. He opened it three years later as the Merchant's House. A lot of the things that happen here are ascribed to Gertrude, even though we have no reason for saying

FOLLOWING:
Ghost Town, Centralia, Pennsylvania
Abandoned House, Frankfort, Maine
Log Cabin, Harlan, Kentucky
Log Cabin, Harlan, Kentucky

She could have sold the house but she didn't
and according to family legend she "kept it as Papa wanted."
She died at 93 years old in an upstairs bedroom.

The first ghost incident we know of in the house took place in 1934 or '35. There was a woman working here who was an expert in period clothing. She felt someone staring at her intently. She looked up and saw a tiny petite woman standing in the doorway with an expression on her face that said, "What are you doing here?" She assumed it was another expert until she realized that the woman was dressed in clothing from the very early twentieth century and the woman suddenly dissolved. There were also a lot of reports during that period that they had trouble keeping workmen on the job, because the workmen reported hearing moans, sighs, and a woman weeping. A workman in the cellar saw a woman wearing a brown taffeta dress. He refused to go back to work and this was in the depths of the Depression when work was not available. Just a few years ago a worker was down in the cellar and he saw something move out of the corner of his eye, he glanced around and there was a woman standing there in a brown dress. He could see right through her.

I have smelled pipe smoke. We have people report quite often the smell of rose water, violets, and burnt toast. A caretaker in the '50s reported walking by the kitchen door and seeing a woman in a brown taffeta dress sipping a cup of tea and looking at the window toward the garden. She blinked, looked again and nobody was there. It's the consistency through the years with the same things happening over and over again to different people who knew nothing about the other reports.

The whole energy in the house has changed over the last ten years. It has a much sunnier and happier feel. We still have experiences although the atmosphere around them has changed. It used to be scary. There was a feeling in the house that someone was yelling, "Get out! Get out!" Now it almost feels like the family is welcoming us because they understand that we care about the house as much as they did. When you enter the house you feel like you're walking into somebody's home, you feel as if they just walked into another room and they are going to come back at any moment. I'm not the only one who walks inside and says, "Good morning." We all feel that they have to be treated with deference and respect because that's what they were used to in life. If you treat them that way, they will deign to allow us to use their home.

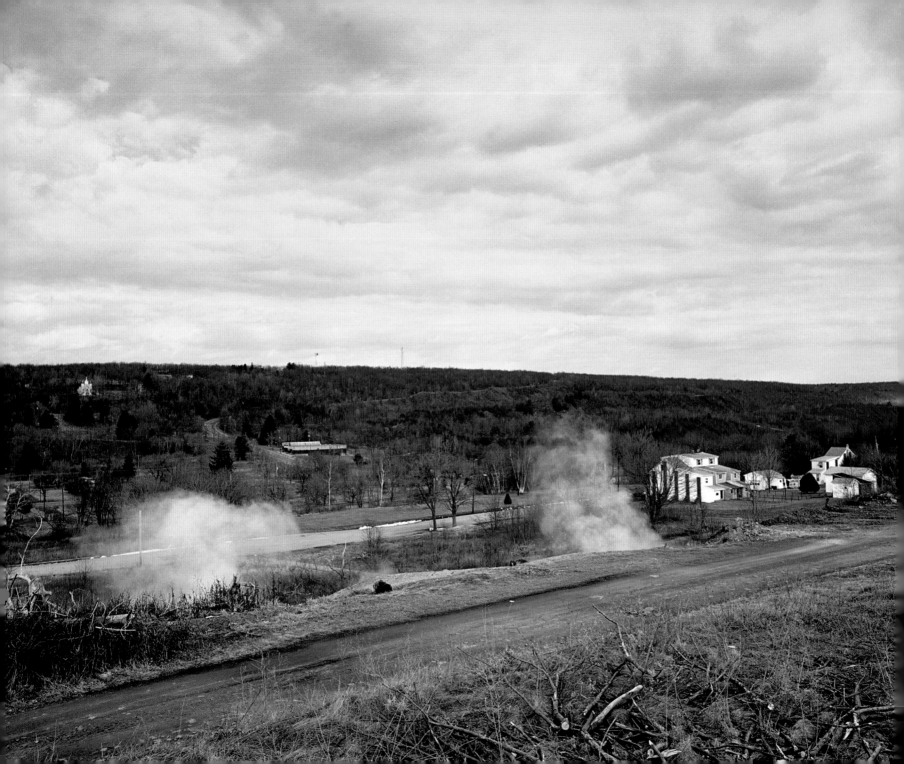

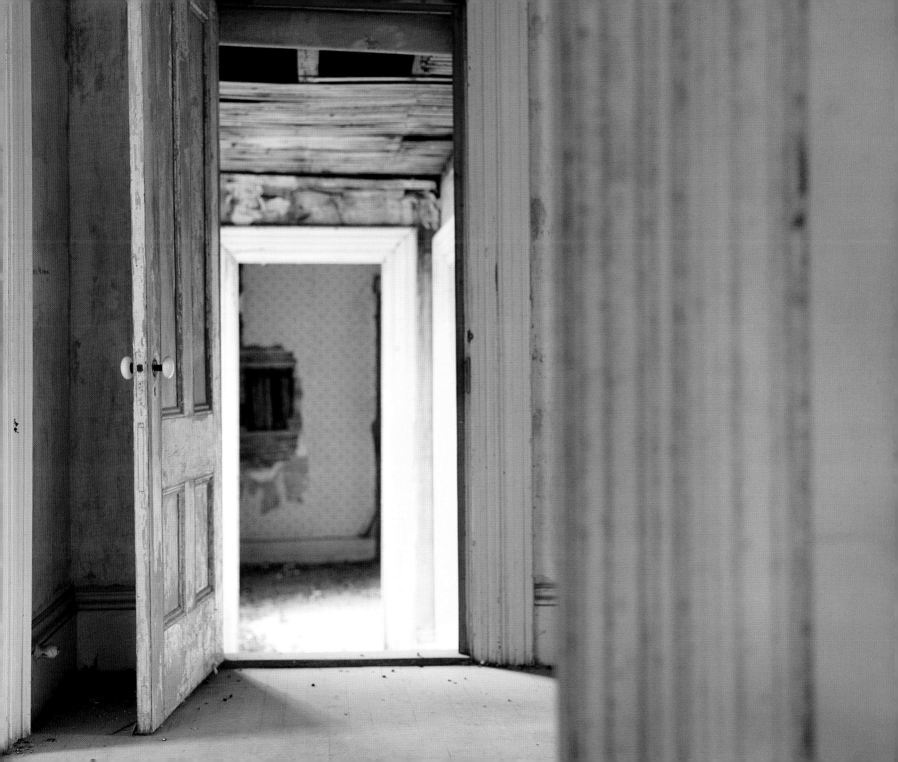

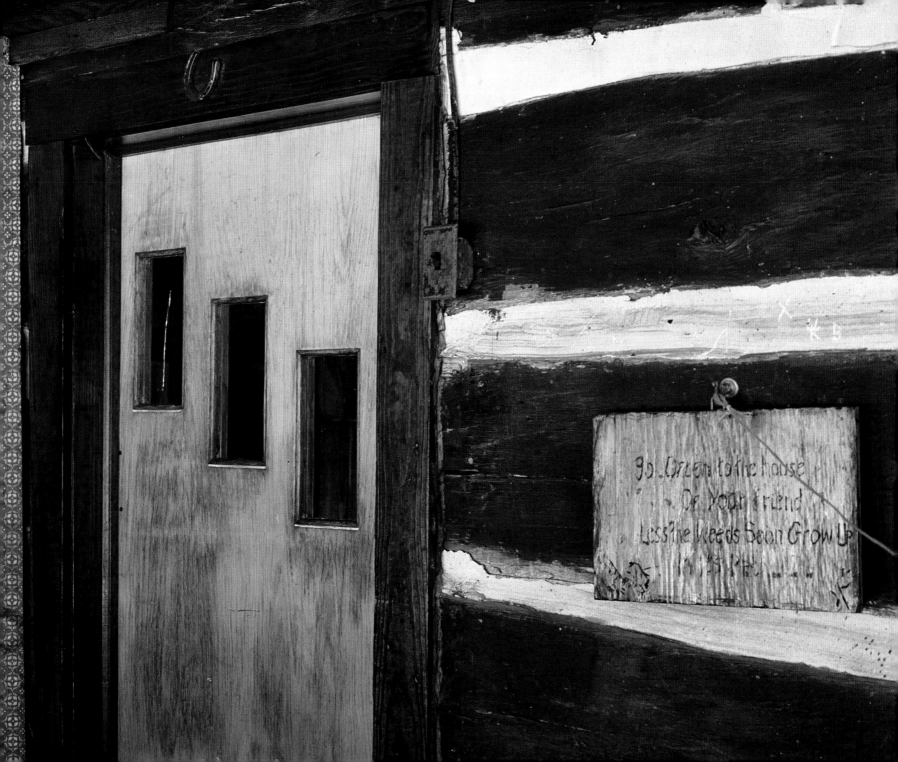

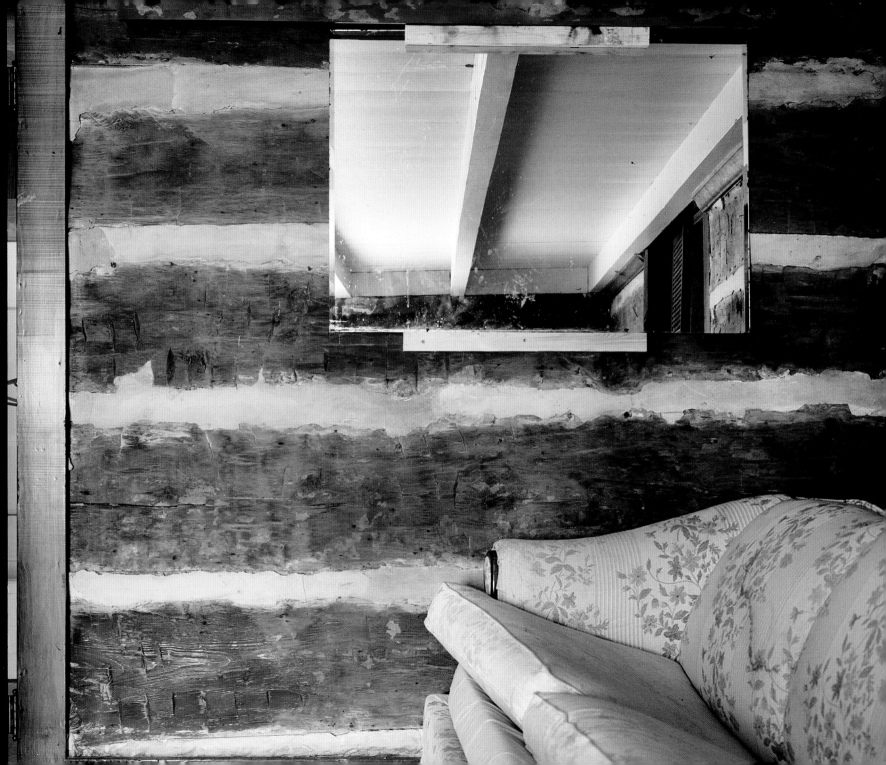

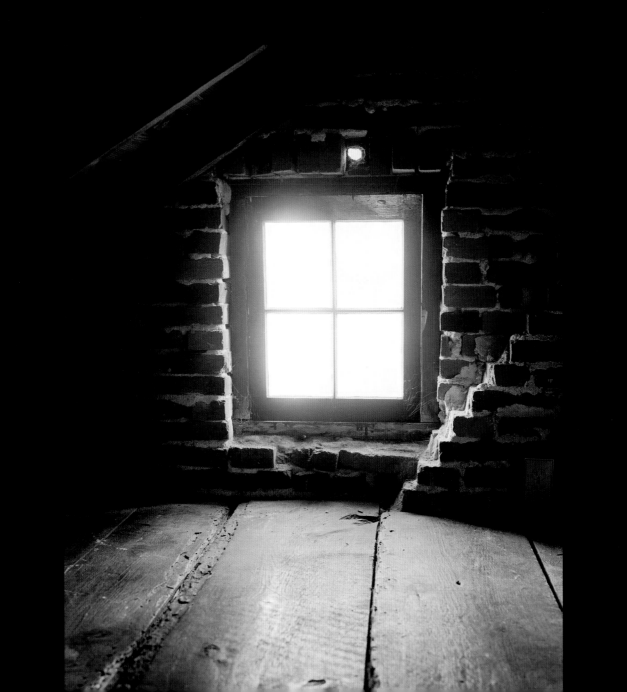

Farnsworth House, Gettysburg, Pennsylvania

BOB

A STORYTELLER WHO RUNS THE GHOST TOURS
AT THE FARNSWORTH HOUSE

I WAS TELLING STORIES DOWN IN THE CELLAR TO ABOUT THIRTY PEOPLE.
About halfway through the show, I saw a black vaporous blob that came down from the
stairs area in the rear of the theater, and it just stood there or hovered for a few moments,
and then advanced toward the front of the theater. As it came forward people actually
slinched away. The temperature dropped so much that a gentleman's breath was vaporizing.
The entity came straight at me and shot up through the floorboards of the house. Afterward,
I was a little concerned about who it was, but at the time it was more like: Am I seeing what
I'm seeing? It was more of a curiosity. It shook people up and several left the theater directly
after this happened.

The house has had a stressful history. The energy, care, and love the current owners have put into the house over the past thirty-some years does not erase the bad history. Before the Civil War a little boy, Jeremy, died in there and his father, William, pretty much lost his mind over it. He had a breakdown and never recovered. William's residual energy is in the house and Jeremy is an entity that interacts with people. He's an innocent spirit. There's a little girl by the name of Sissy who died of a lung ailment and a lot of sadness comes with her. There is also the energy of an owner that you don't want to encounter. The Farnsworth reputation for being haunted is deserved. The house has a strange energy, as far as the "permanent" residents are concerned. It feels like the house is alive.

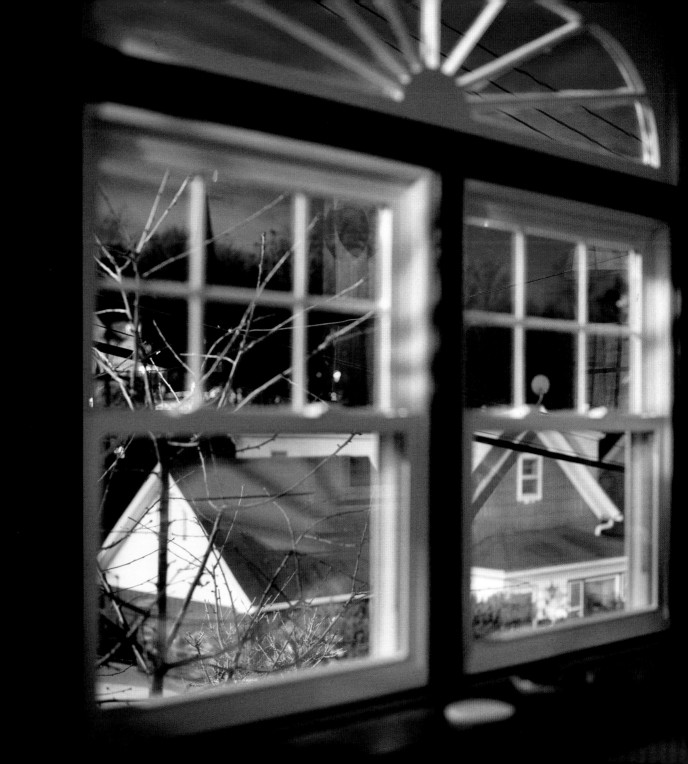

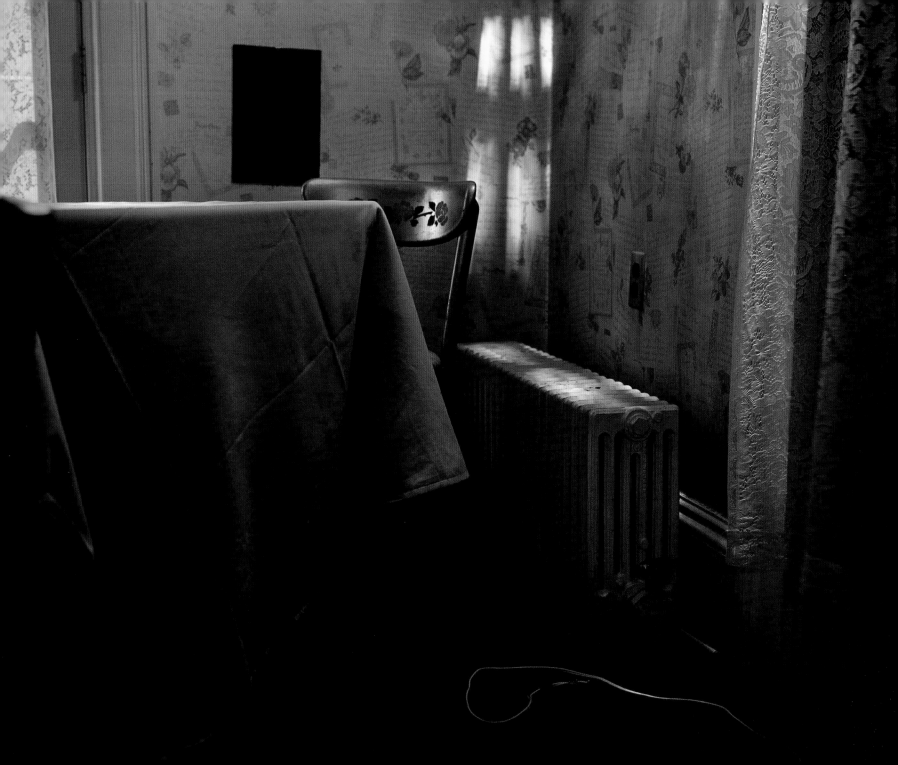

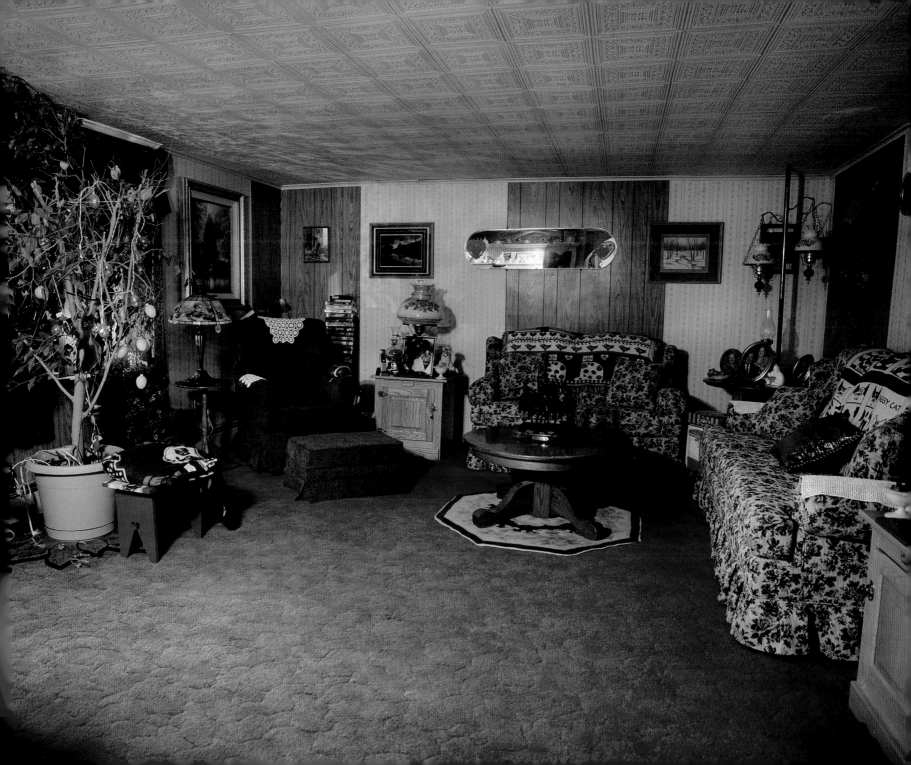

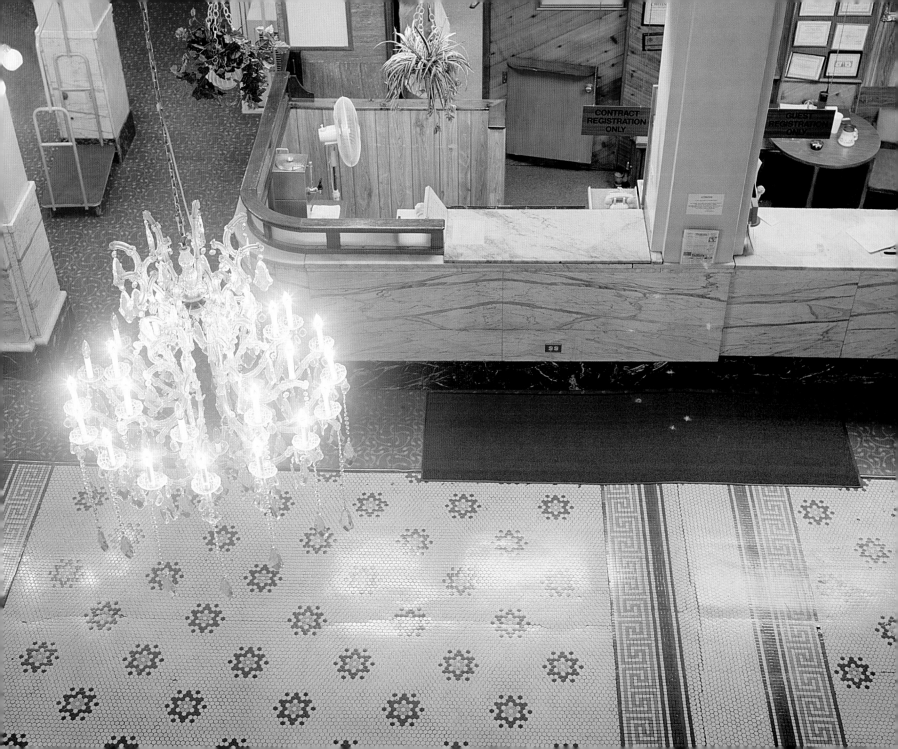

Private Residence, Clinton, Maine

FRANK

HAS LIVED IN THE HOUSE FOR OVER SIXTY YEARS; HE WAS 81 YEARS OLD AT THE TIME OF THIS INTERVIEW

YOU CAN CALL IT WHAT YOU WANT. I DON'T KNOW WHAT TO CALL IT, BUT THERE'S SOMETHING THERE. Don't bother any of us; that's all I know. Creaking floors, noise. There was an old man, Mr. Brackett, who fell in the well and drowned about sixty-five years ago, so the noise that we hear can probably be attributed to him. The Bracketts were the original owners. The place was in the family from the time it was built until he died, and then it went to his daughter, but she's dead now.

Somewhere around fifty years ago, I was lying on the divan in the living room. With the moonlight shining on the floor I saw the rug actually depress. It headed right across the room to where I was. I could see the rug move as if someone was walking on it. I turned the light on and

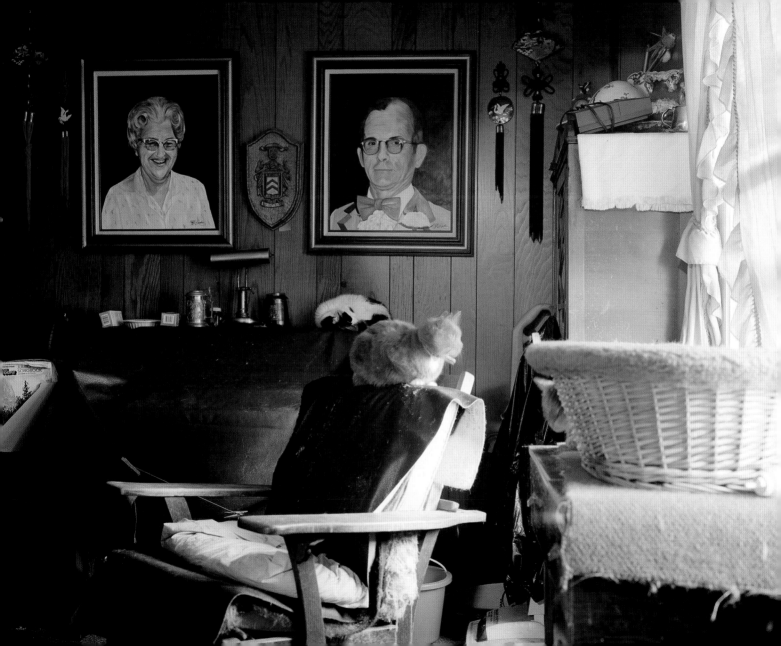

> I waited a few minutes,
> turned the light back on,
> and the face was gone
> but there was blood
> on the floor.

there was nothing in that room whatsoever. I still don't know what it was. There's a lot of things that happen. Doris hears things in the house. I can't hear now because I'm hard of hearing. I used to hear a lot of different noises and there would be nothing there. You hear all these things but you don't get hurt or anything. The good Lord only wants you to know so much and that's it.

DORIS
GREW UP IN THE HOUSE AND LIVES THERE WITH HER FATHER, FRANK

WE CALL THE GHOST MR. BRACKETT. Most everybody in the family has had some experience in the house. My mom saw some apparitions that would come and go, kind of a floaty sensation. Mr. Brackett had a daughter who was wheelchair bound. In the house today you can see certain places with the old boards on the doors where she would hit the wheelchair edges. My understanding is that she fell down the cellar stairs and died. How true that is, who knows? You hear a lot of things that go on.

Years ago when my parents first moved in, my dad got ready for bed one night and his pocket watch dropped onto the floor. He leaned down to pick it up but he couldn't find the watch. He looked all over the floor that night, under the bed, he hunted everywhere but he couldn't find it. The next day my mother moved everything around and couldn't find it. Months and months went by, one night he was sitting on the bed, and the pocket watch dropped out of nowhere onto his lap. It was the same watch, it was running and it was the correct time. It was a wound pocket watch. How it happened, who knows? He got his pocket watch back. This has been passed down to us kids for years, he always told us the same story.

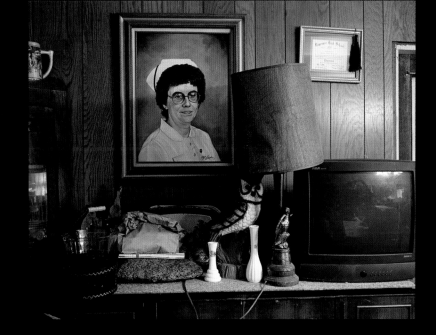

One night, I heard something and woke up. I looked down to the foot of the bed and saw a really ghoulish face. When I finally got courage enough to turn the light on, the face was still there. It was bleeding and I was so scared that I shut the light back out. I waited a few minutes, turned the light back on, and the face was gone but there was blood on the floor. That was the only time that I had a bad experience in the house that really scared me. I was young at the time. It took me a while to get over that.

I've also seen my neighbors across the street a few times. Especially Stanley. Stanley hung himself in the barn when I was about eleven or twelve years old. I remember seeing him hung in the barn. Many years after that I saw him walk out onto the driveway several times. He's quite the formidable man, believe me. I think that our spirits have to go somewhere and if they're not happy and at unrest they're gonna stay around until they find peace. I think there's a reason why they do stay here. I think if a spirit visits you, or a presence, there's a reason why you've been chosen. I think you have to look at it as you're tied to that spirit or person, or they want to make a connection and go to a different level of being.

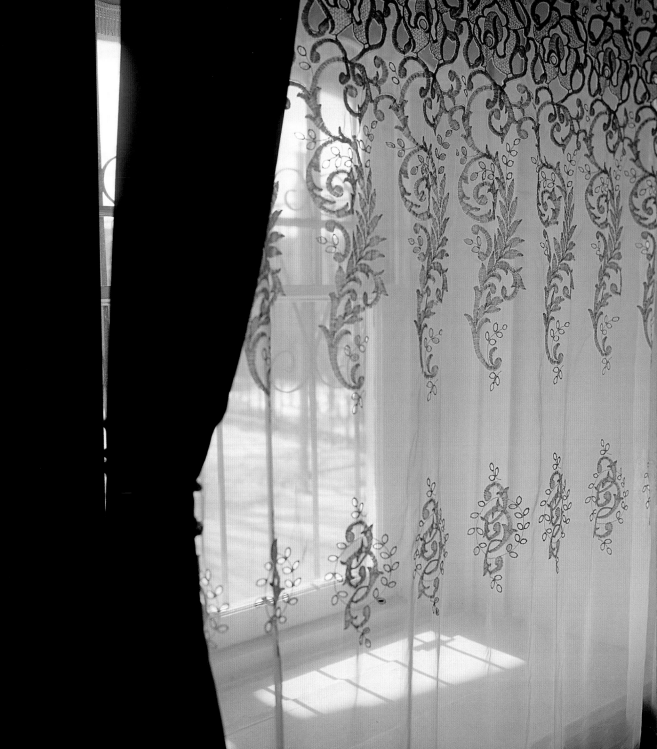

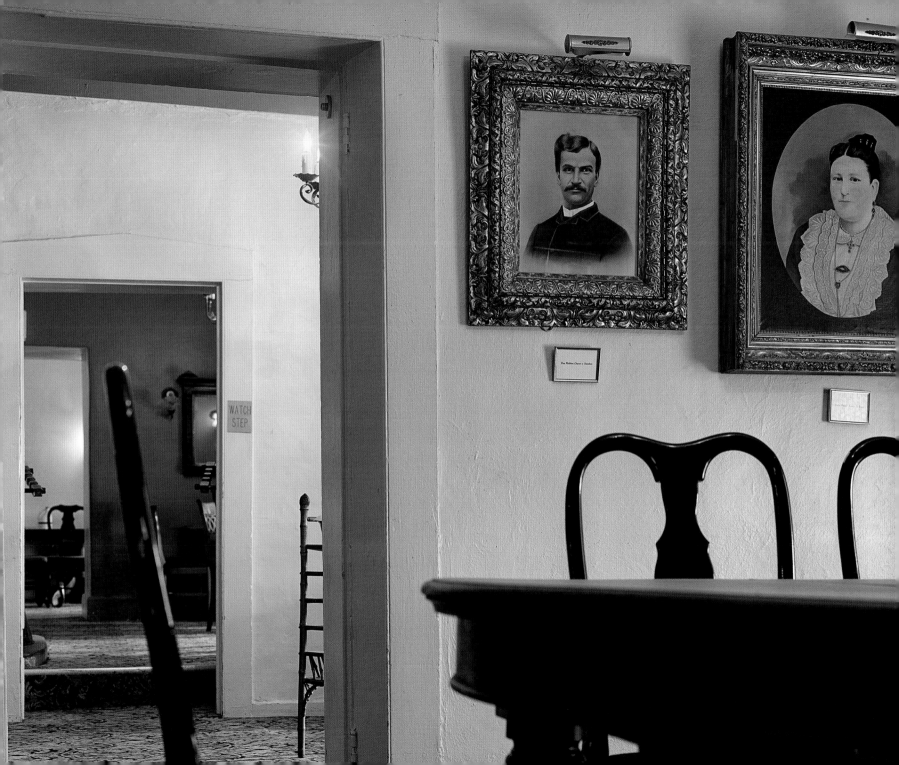

WATCH
STEP

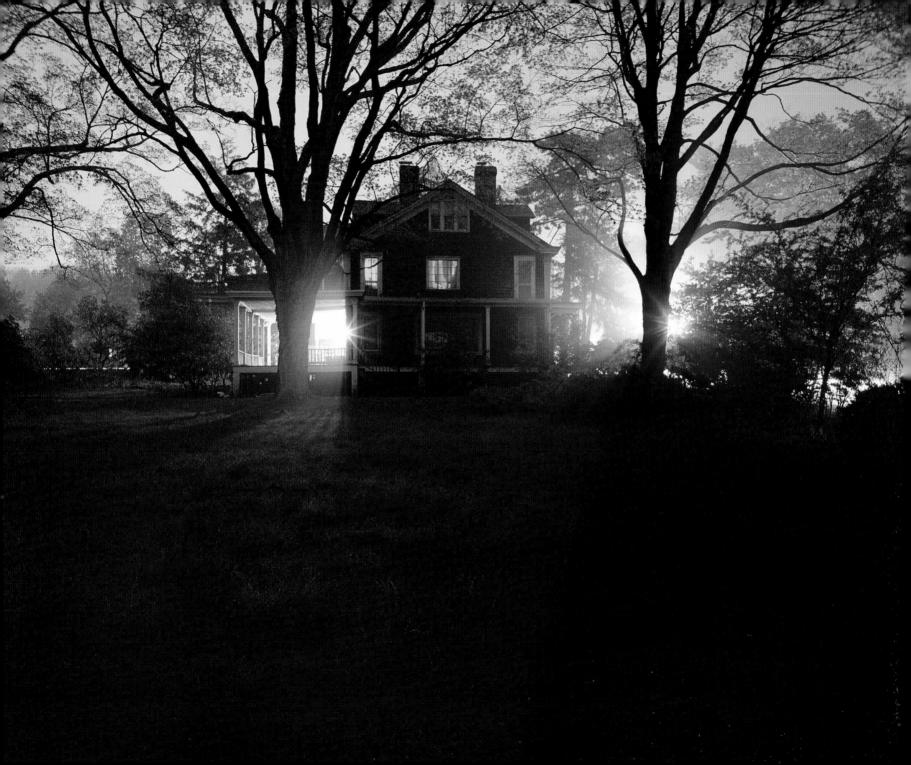

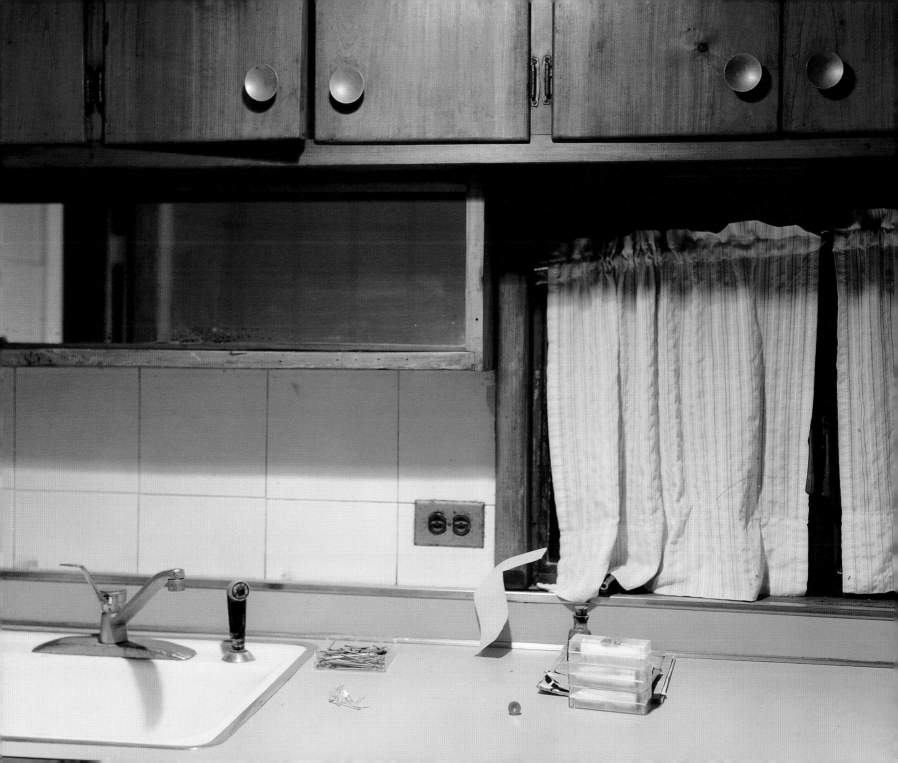

The Church of St. Barnabas
Irvington-on-Hudson, New York

CHARLES

SERVED AS RECTOR OF THE CHURCH OF ST. BARNABAS FOR THIRTY-SIX YEARS

I NEVER BELIEVED IN GHOSTS UNTIL I CAME HERE THIRTY-FOUR YEARS AGO. It's hard to be at St. Barnabas without coming to believe in ghosts because they are all over the place and a lot of people have experienced them. My framework for understanding this is a phrase we use in our worship, which says, "I believe in the communion of saints." This means that there is a fine line between heaven and earth, that those who have died are really very close to us, and we're all part of the same fellowship or communion. We are all interconnected. Heaven breaks into this realm all the time: why should we be surprised when somebody appears? I have had people appear to me, loved ones who have done things to let me know that they're here. They've touched me on the shoulder, they've come at a specific time, and my wife has actually

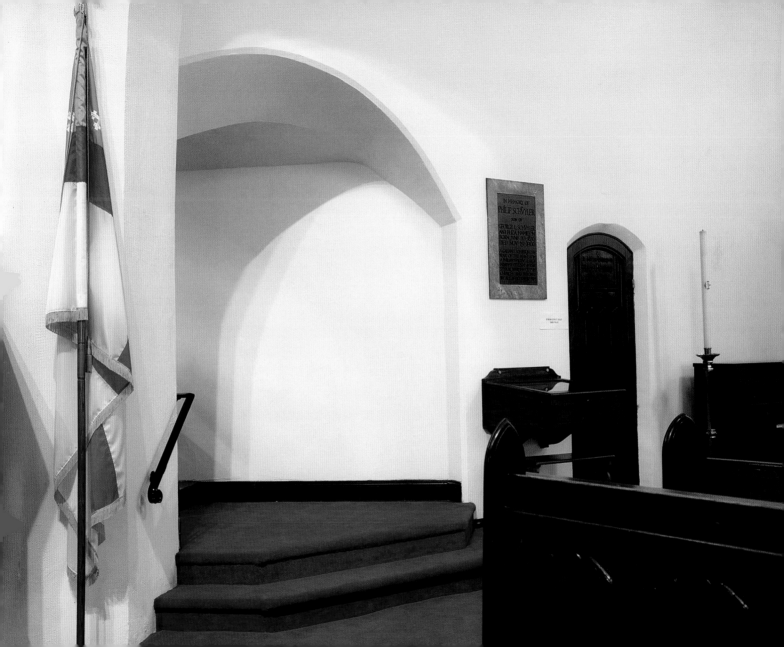

had people appear in front of her. A couple of winters ago she was watching TV late at night in the kitchen and a woman's head appeared next to the television set. It looked like Mrs. Benjamin, the second rector's wife, with a bun on the back of her head. They lived in the house for forty years. She stared at my wife as if to say, "Why are you up so late?" And then she just faded and Judy went to bed. [Laughs]

My daughter was very young and she had her own bedroom upstairs in the rectory. She would wake up in the middle of the night repeatedly and say to my wife and I, "There's a woman sitting in the rocking chair, she's wearing an old-fashioned dress, her hair is in a bun and she's knitting. She keeps looking at me. Why does she do that?" We said, "Go back to sleep, it's just a dream." We didn't take it seriously until six years later, when my daughter was thumbing through a book about the history of the rectory and came across a picture of Mrs. Benjamin in an old-fashioned dress and a bun. She exclaimed, "That's the woman I was trying to tell you about!" They lived in the rectory so long it's not surprising. People wonder why she would come back, and there are lots of theories like people are stuck and they can't move on. I think that's utter nonsense. That's a projection. I think that for whatever reason they drop in for a visit.

An elderly woman told me the following story just before she died. She had been a schoolteacher and very scientific minded, not prone to things like ghosts. She told me that she saw Dr. Benjamin in the sanctuary of the church. She was on the altar guild and she looked up in the sanctuary, and Dr. Benjamin was standing there looking at her. He stared at her for a long time, and then he turned and walked through the wall. It was especially meaningful coming from her because she wasn't prone to telling tall tales. Other people have experienced ghosts when they're going upstairs over the parish hall; they feel like someone has brushed past them. We had a new organ put in five years ago. The builders were working on the organ and there was a big thundershower. It became very, very dark in the church and there was a bolt of lightening that lit up the church and one of the workmen saw this man standing in front of him. He was freaked out! He said the man just stood there and then the lightening disappeared and the man disappeared. He got out of the church as quickly as he could! [Laughs]

Two years ago in the rectory the hot water faucet in the downstairs bathroom would suddenly go on full steam. We would go and turn it off and it would be fine for weeks. It never happened when we were away; it always happened when we were around and could hear it. One time I was standing just around the corner from the bathroom door in the dining room and it went on. I thought, this has got to stop. So I said to the ghost, "Look, it's fine that you're here, but you've got to stop this and stop it now. We're not allowing this in this house. It's too freaky and it's scary. You're not in charge of the faucets so just stay away from them. Thank you, goodbye." It happened once more and the second time I said, "This has to stop now! I'm telling you it's not to happen again." It didn't happen anymore.

I remember sitting in the kitchen one night and we were talking politics. Suddenly this hand—not like a muscle twitch—but this hand was really pressing on my shoulder. I knew it was my mother-in-law because she would have agreed with me. [Laughs] Her presence appears quite often in my own story because she was very important in my life, and I loved her dearly. Some fifty percent of people are experienced by their loved ones after they die in a dream or by something coincidentally falling down, like a picture that would identify the deceased, or they see them when they're wide awake. I

People wonder why she would come back, and there
are lots of theories like people are stuck and they can't move on.
I think that's utter nonsense. That's a projection.
I think that for whatever reason they drop in for a visit.

know dozens of people that it's happened to. I don't know how you scientifically deal with that. I'm sure there are ways of saying that it was a bad dream or a projection, but it happens and it's not surprising believing in the communion of saints as I do. I think, "Yeah so? What's so surprising about it?" There's a fine line between the next world and this. It's all one reality and we can't divide it up, reality is reality. We

know a little bit from Einstein about time, relativity, and space, and that one interacts with the other. Time is a human construct anyway. I love time-warp stories. The theory is that if you go fast enough you can go back or ahead in time. Who says there's a great division about past, present, and future? Who says that we can't visit those places in the so-called past? Now is all we have.

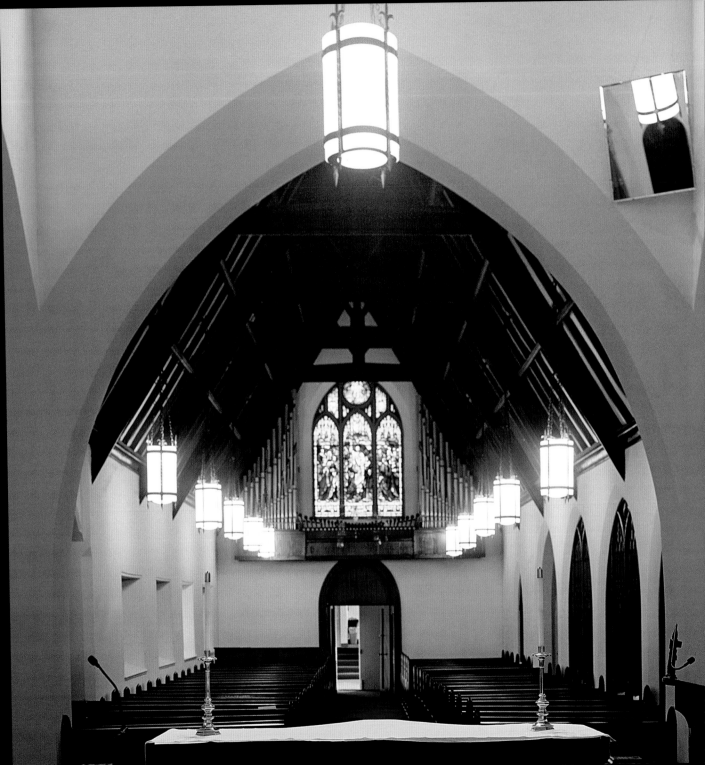

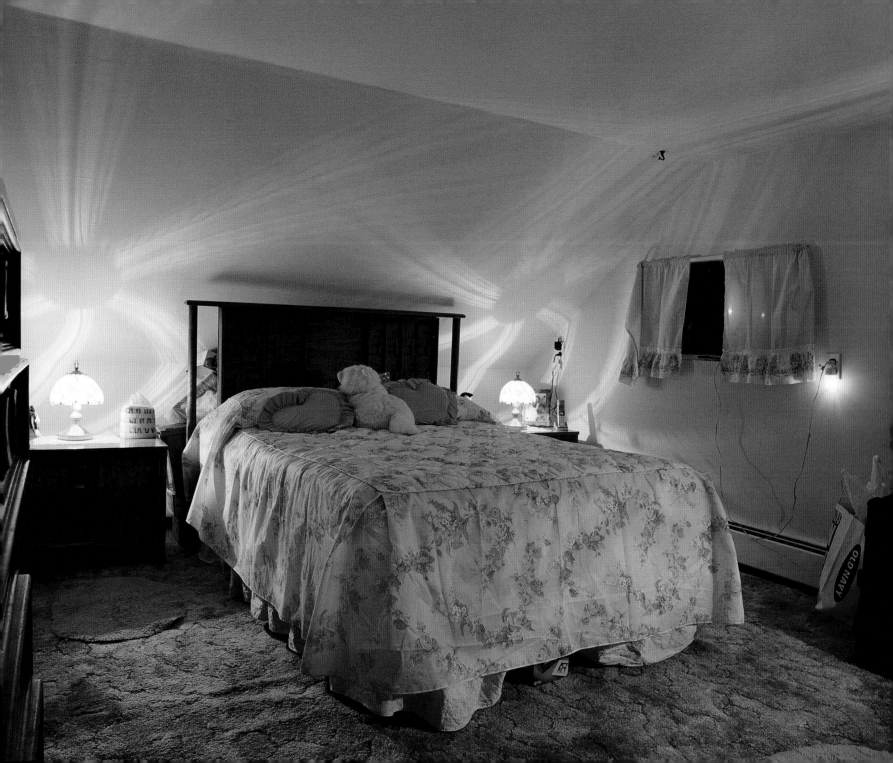

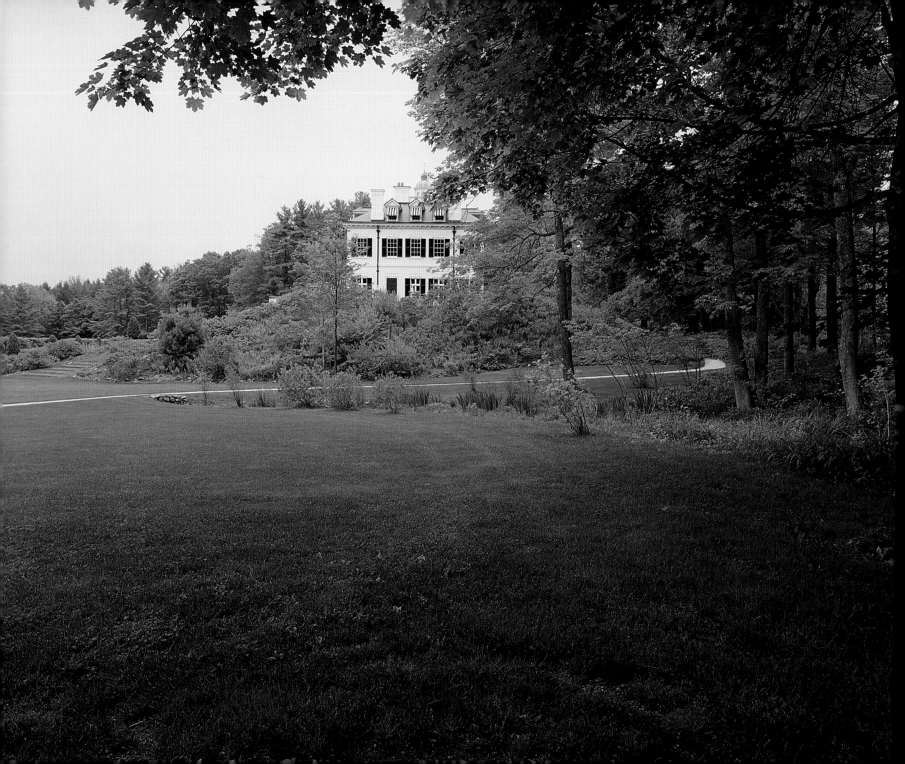

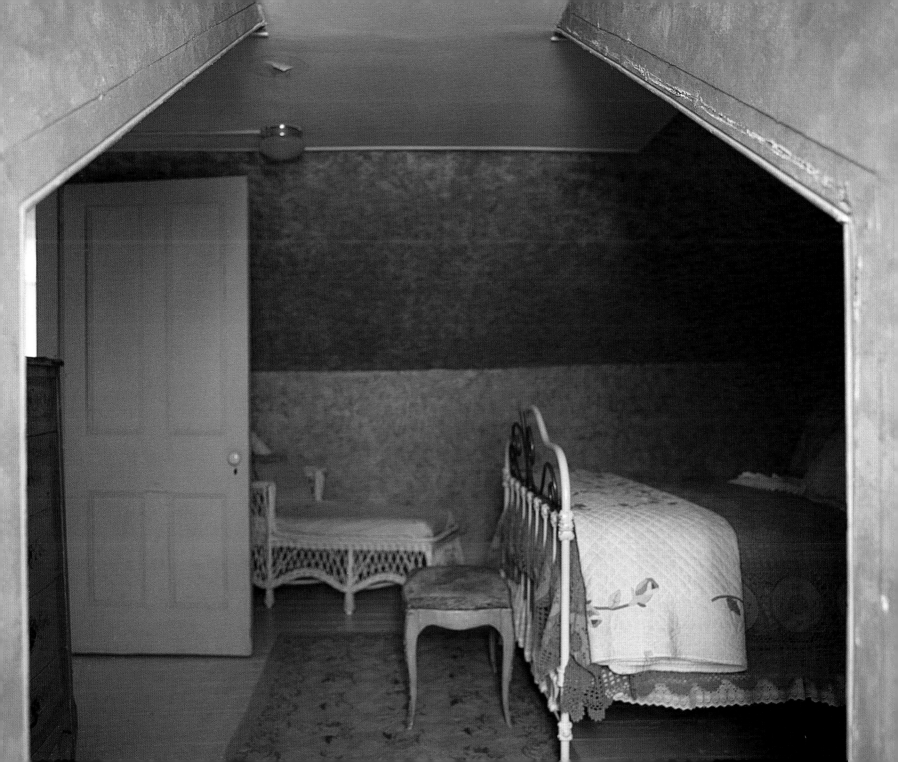

ELAINE

WHO HAS LIVED IN THE HOUSE WITH HER
HUSBAND SINCE 1983

GHOSTS ARE BOTH BENEFIC AND MALEFIC. IF YOU WERE A GOOD PERSON IN LIFE YOU'RE GOING TO BE A GOOD PERSON IN DEATH, TOO. My resident ghosts are very benefic and they look over the house. Many years ago I had a bunch of psychics over to find out who the ghosts were. The two main ghosts include a man from around 1820. He is short, about 5'4", rotund. When he's around you can smell his cigar smoke. The other ghost is a woman from around 1890. She told one of the psychics that having red carpet was disgusting and no decent people have red carpet. She would prefer that I get rid of it but it's still there.

Most of the activity has been upstairs. Both my husband and I have been in bed and felt the ghosts of our deceased cats jumping on us and curling up. When we first moved here our dogs

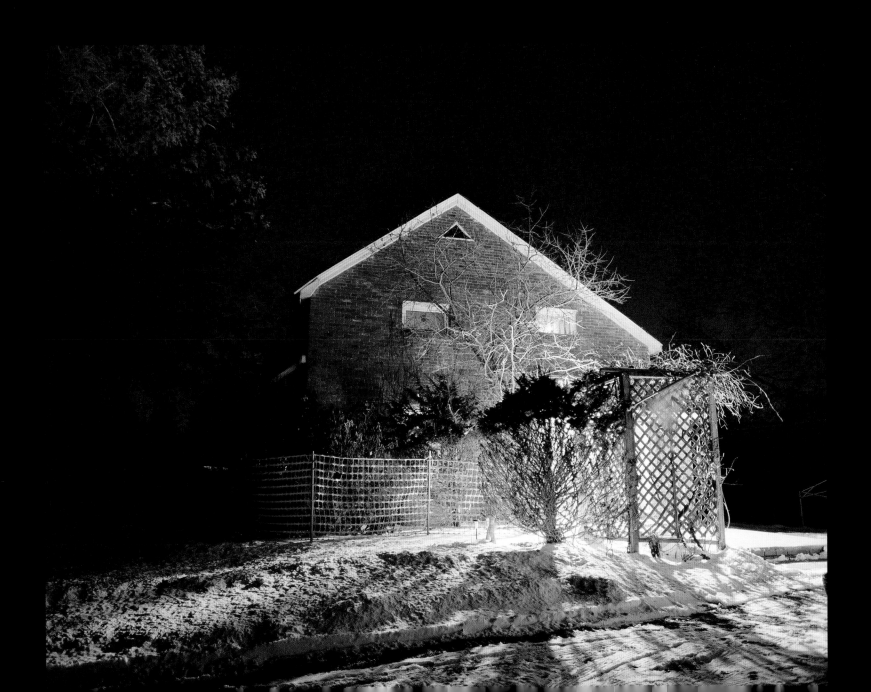

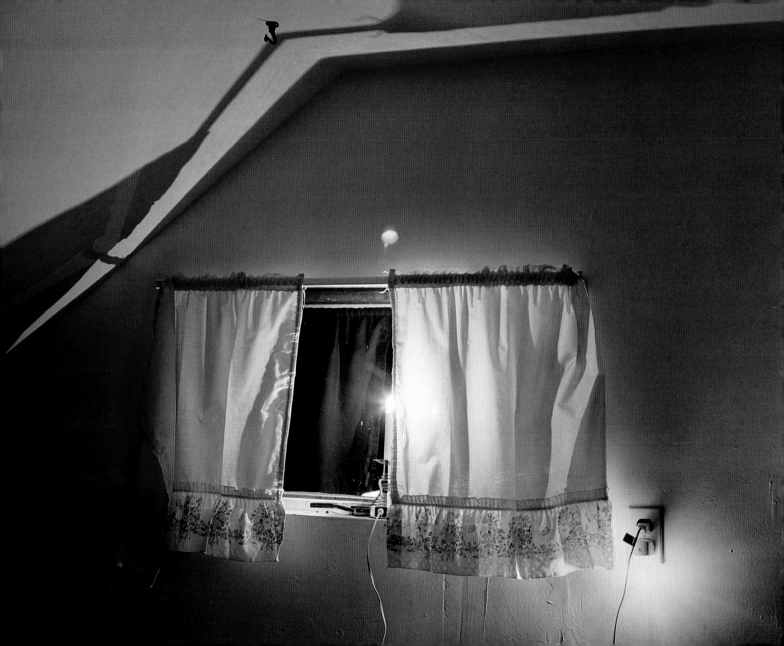

refused to come upstairs because they sensed the ghosts. One night I was sitting in my bed and I saw this woman standing by the railing, bending down and looking at the dogs. I also saw the same woman in the laundry room when I was on my hands and knees scrubbing the floor. She walked right by me and I could see the bottom of her skirt. She was dressed in a white blouse with her hair in a bun.

I think they protect the house, I really do. I feel that if somebody were trying to break in, the ghosts would scare the pants off them. My friend said that since we've lived here the atmosphere has really changed; it was so scary and evil before and now it's so warm.

JENNA
ELAINE'S TWENTY-FOUR-YEAR-OLD
GRANDDAUGHTER

WHENEVER I COME IN, IF MY GRANDMOTHER'S NOT HERE I THINK, "DON'T COME TO ME!" I don't want to see anything. I've been here a hundred times and I still get scared. When I was little and my grandmother was tucking my sister and I in, I smelled cigar smoke. I asked my grandmother what it was and she said, "I'll tell you when you get older." Years later she told me that the male ghost in the blue bedroom smokes cigars. When I was ten years old, I saw the ghost of a little boy in her living room on Christmas. Since I'm at my grandmother's house a lot I think they know they can communicate with me because they come—the little boy and the woman—in my dreams. The woman told me her name was Mary and when I woke up I was upset that they could enter my dreams. Regardless of how uncomfortable I get, I'm drawn to the house. The rooms feel vibrant and alive.

Whenever I come in,
if my grandmother's not here
I think, "Don't come to me!"
I don't want to see anything.

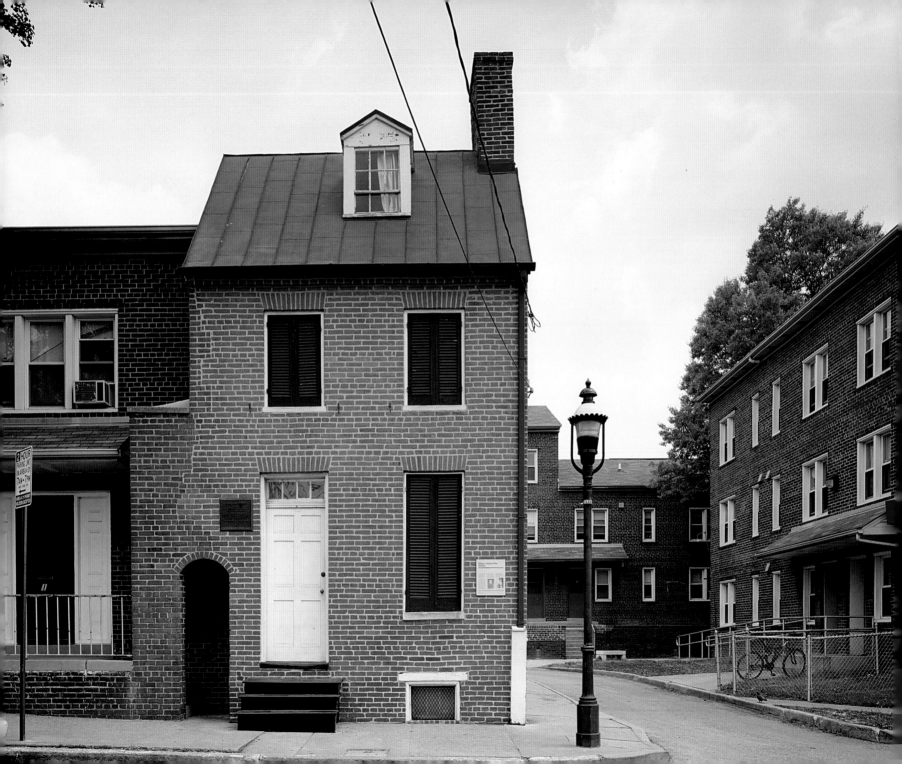

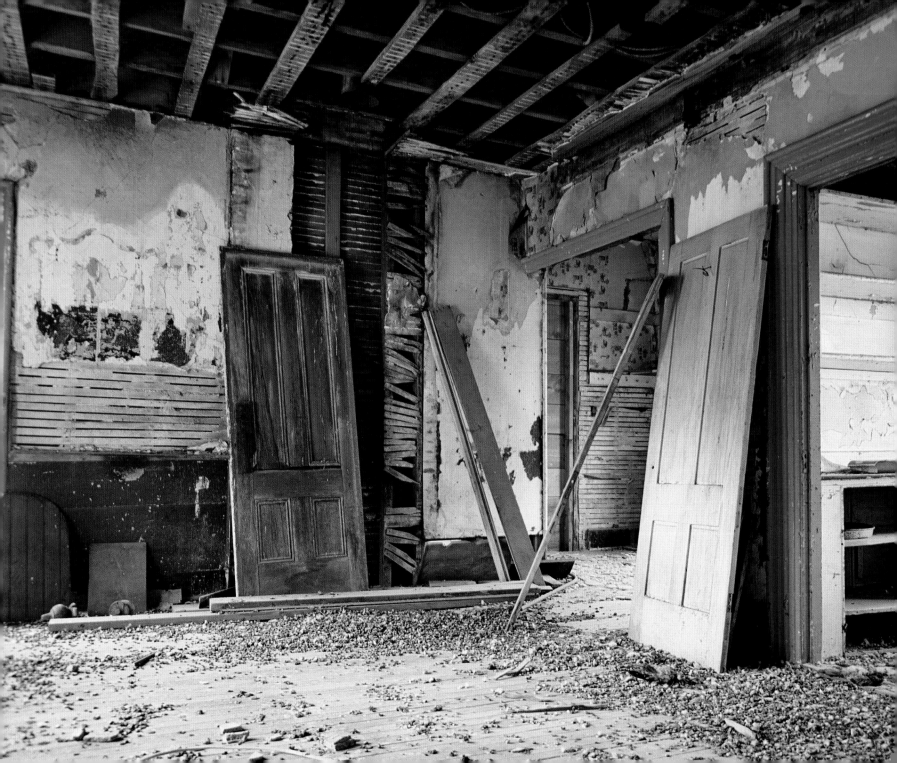

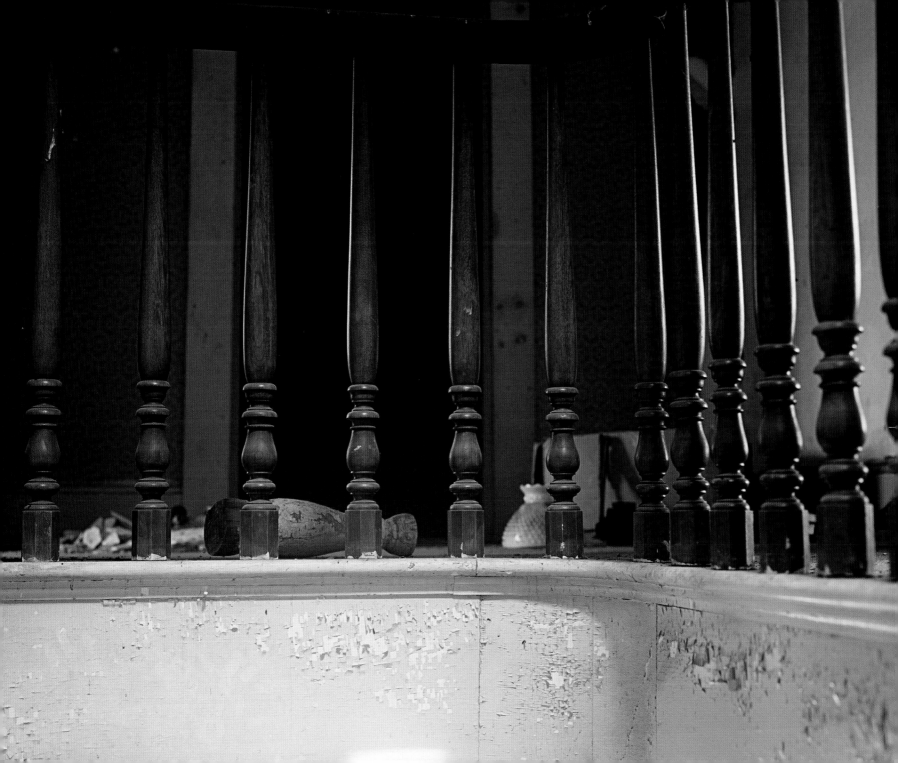

Abandoned House, Frankfort, Maine

CHERYL
LIVED WITH HER FAMILY IN THE HOUSE
FROM THE 1950S UNTIL THE 1970S

MY SISTER AND I ALWAYS HEARD OUR NAMES CALLED. My father always said it was the wind, but the wind don't say your name. I didn't like going up on the third floor, that's where I saw a man sittin' in an easy chair. Sometimes it sounded like people were walking around the house and running down the halls. When we first moved there the floor in the back room was all cluttered with love letters. Maybe that guy died there or somethin'. That place made me feel so weird. My mother died in the house the day we were moving out; I feel like a part of her is still there. It was always cold in the house so my mother was happy we were moving to a warm place. The moving vans had just left, she was finally gettin' out of the house and she never got out. As bad as I wanted to leave cause it's creepy, I miss it. I'm not sure if it's true but I heard that the man who bought it won't stay there 'cause it's haunted. The place has been empty for a long time.

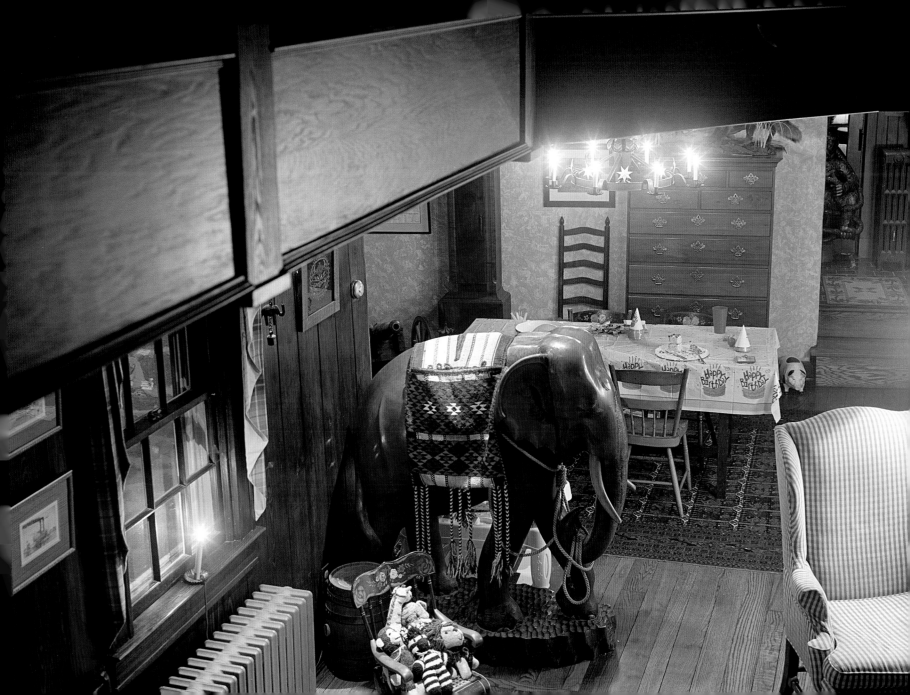

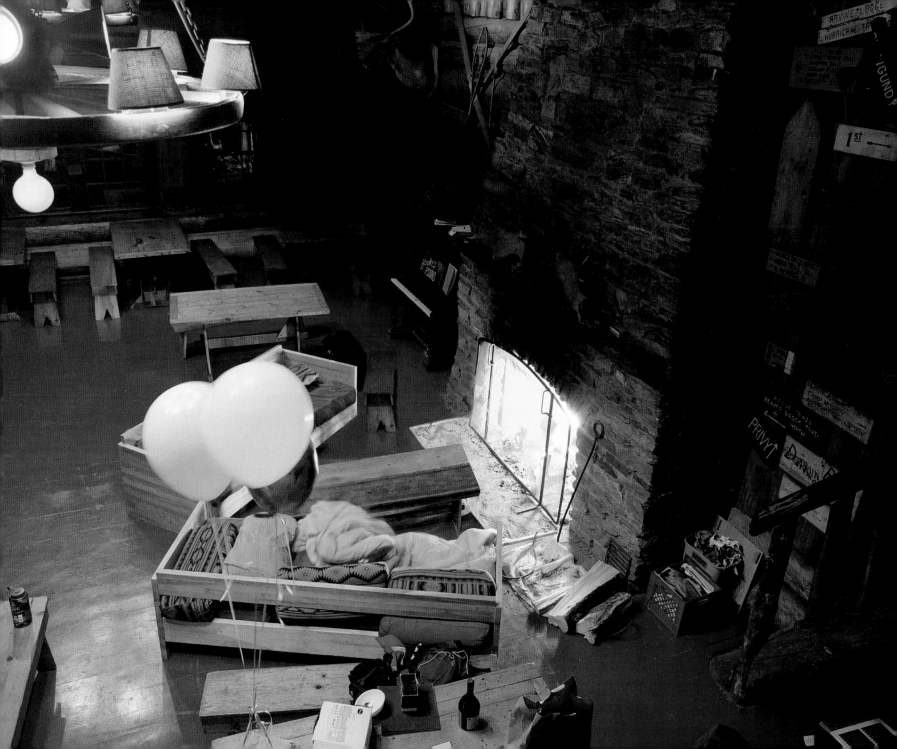

Historic Inn, Harlan County, Kentucky

DANNY, MAINTENANCE MAN

THE NINE YEARS I WAS THERE I SEEN 'EM 'BOUT FROM DAY ONE TILL THE TIME I QUIT. The ghosts just got to where they know'd me an' felt secure around me. There's a colored man in the basement, he didn't hardly associate with nobody. He very seldom leaves, but if he comes out of the basement, he'll be in the gym. He told me he was the janitor; that furnace blew up an' kil't 'im back in the early '30s. Like a solid person you could see 'im. He wears old bib coveralls an' a khaki-color shirt. If he wanted to ask me somethin' he'd ask me.

He'd helped me on the job. We had an ole coal hopper. I ha'ta shovel the coal on the outside, an' after 'bout five or six times, go down to the basement, an' move it on a metal shoot. I'd move one side an' he'd move the other side. He did lil' things like that. He saved me two

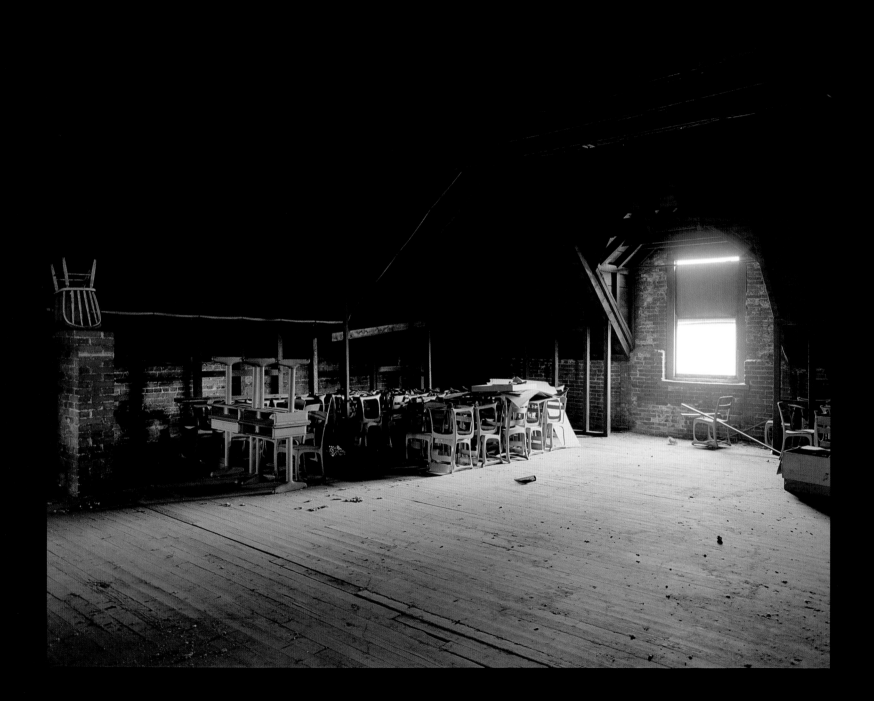

or three times from gettin' burn't. He knock't me out the way once when the boiler busted an' the water squirted out. If I hadn't'a got knocked outta the way I woulda got scalded to death. Another time, I was workin' on some 'lectric wires near the breaker, an' a four-inch water line busted. Right before the water line busted onto 'em power wires I ended up somehow—I don't know how—goin' through a wall into another room. Somethin' shoved me through the wall, an' I tore the block out where I went through.

I was workin' with two boys an' I told 'em, "Stand still." They said, "Why?" I said, "S-t-a-n-d still. I'm a gittin' a message there's a snake fixin' to strike one of us." I asked that ghost, "Where's it at?" He said it's near the radiator. I told that boy, "Gimme yur hand." He gave me his hand an' I gave 'im a quick jerk. As I jerked 'im away the snake struck up where he'd a'been standin'. He got away from the copper head just in time. The men with me didn't know the ghost was talkin' to me, they didn't hear 'im, see 'im or nothin'.

There's a lil' girl that plays on the first floor hallway. The lil' girl always got a pink shirt an' pair of blue jeans. She's 'round nine, maybe ten years old. Then you got a lil' boy who told me he got kil't in the gym. He was twelve years old when he got kil't. On June the 4th 2000 the lil' boy give me a nickel with a cross in it. He told me, "You keep this nickel an' you gonna catch the biggest fish you ever caught." That mornin' we went out to the lake an' I told my boy, "Son, we gonna catch us a fish." He poked fun at me 'cause I never had caught a big fish. That mornin' I caught me a fish, weighed 103 an' a half pounds an' was 68 inches from one end to t'other. Funny thing, the nickel was dated 1995, the very year I started workin' there. [Laughs] I keep it in my billfold.

They get excited playin' in the hallway, an' they come runnin' through you. It happened with the children 'bout four times. When one runs through you, Lord, that's a feelin' you won't forget! It takes the breath outta yur lungs an' you don't feel yur heart movin', not for a minute. You think, "Did they shoot me or somethin'?"

I was changin' a hallway light bulb an' the lil' boy come runnin' an' knock't me off the eight-foot stepladder. I was off work for near 'bout three days on account of that. After I went on back to work he apologized to me. I was eatin' my dinner an' he came up to me an' he said, "Sir, I am so sorry that I knock't you off of that pole." He called it a pole instead of a ladder. I said, "Well, I forgive ya."

When one runs through you, Lord, that's a feelin' you won't forget!
It takes the breath outta your lungs and you don't feel your heart movin',
not for a minute. You think, "Did they shoot me or somethin'?"

Some people rented a room, claimin' they were ghost hunters. I said, "Come back in the fall. I guarantee you they'll be here." The ghosts are more active in the fall, startin' t'ward the end of October, an' 'specially 'round Thanksgivin' an' Christmas. You hear 'em playin', hootin', hollerin', an' runnin' in the halls at nighttime. The ghost hunters come back in December an' I told 'em, "Git yur meter out an' come down." His meter swung outta sight. I asked 'im, "Are you a believer?" He said, "What you mean?" I said, "Do you believe in the Holy Spirit? What kind of Christian are you?" He said, "I don't believe in that." I said, "Yur a ghost hunter an' you don't believe in it? Then yur stupid." He looked back at me, an' I looked down the hall an' I said, "In the name of the Father, Son, an' the Holy Ghost, appear!" Three of 'em ghosts appeared in the hall, an' the men ran outta the building. They ain't no ghost hunters!

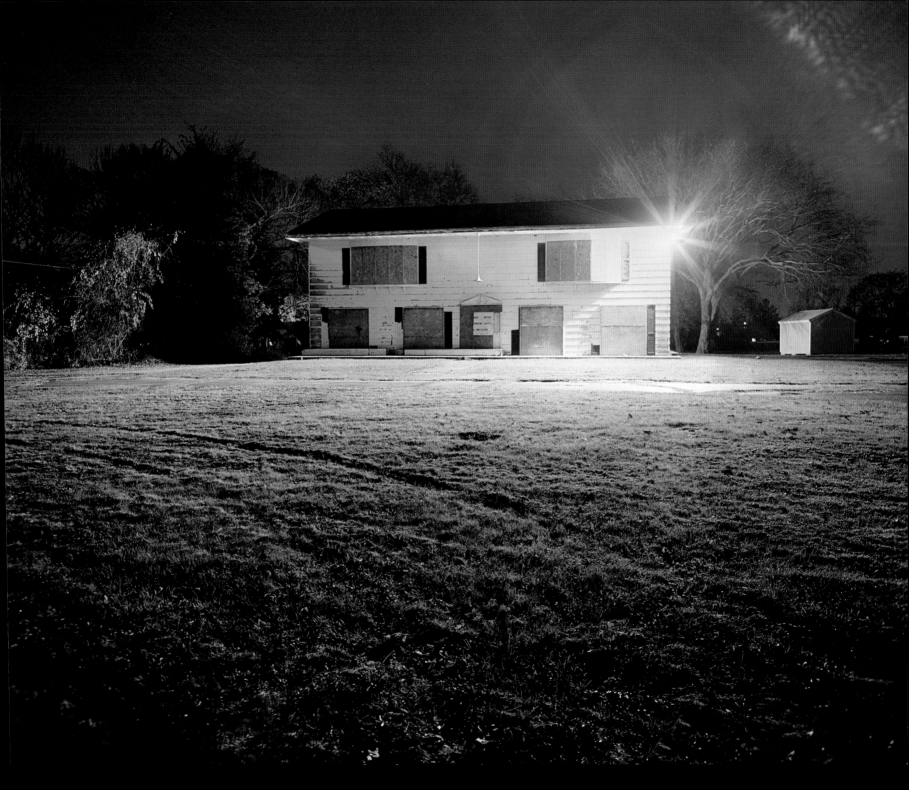

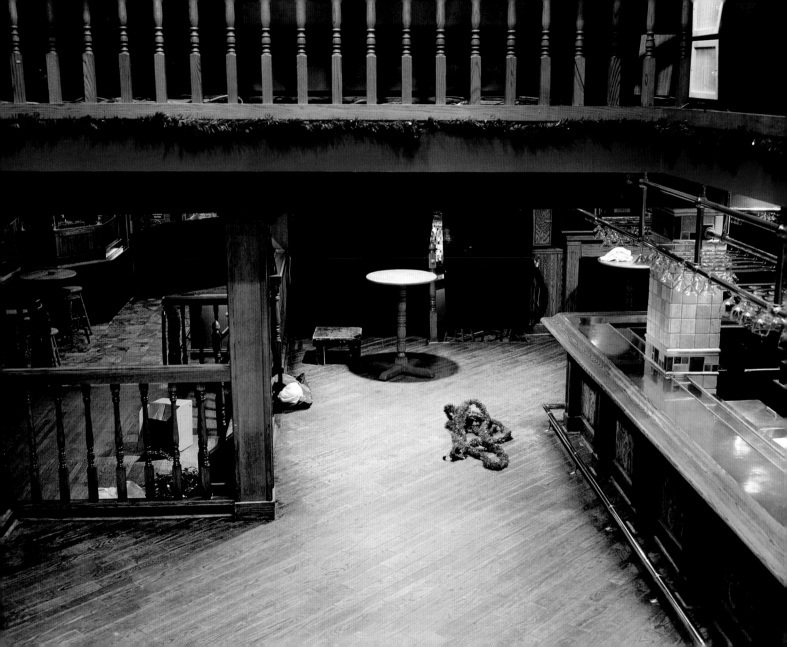

Sayre House, Morristown, New Jersey

BETZ

RESTAURANT MANAGER OF JIMMY'S HAUNT, A RESTAURANT THAT WAS LOCATED IN THE HISTORIC 1749 SAYRE HOUSE

I'LL BE WALKING DOWN THE SECOND-FLOOR HALLWAY, AND I'LL HEAR COMPLETE CONVERSATIONS BEHIND ME, WHEN THERE'S NOBODY THERE. When I close, there's usually a bartender here with me and I lock the front door when everybody's gone, and then do a walkthrough to make sure nobody's hiding in the building. One night we were down at the lower bar and there was absolutely no one else in the building. The bartender and I were in the middle of a conversation and we both heard this noise—like breaking glass—and we had no idea what it was. I still don't know what it was. Stuff like that happens a lot.

I had two customers who told me that when they were at the booth having dinner their wine glass moved about four inches across the table. A lot of people that work here are

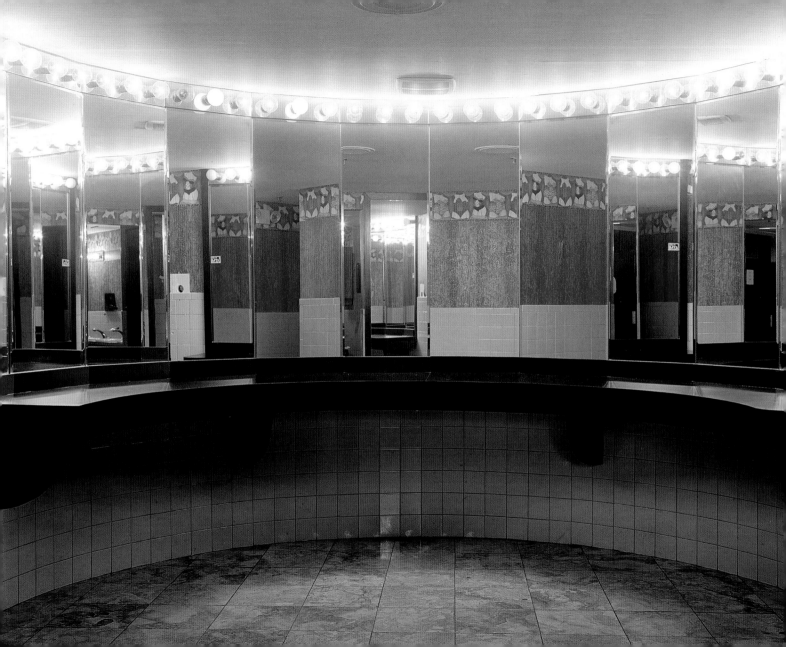

FOLLOWING:
Roehrs House, Franklin Lakes, New Jersey
Moosilauke Ravine Lodge, Warren, New Hampshire
Rental House, Upstate New York
Moosilauke Ravine Lodge, Warren, New Hampshire
Private Residence, Dobbs Ferry, New York

I walked in and it was like I was physically stopped.
You know how if you run into a wall you physically bounce back?
That's what it was like.

really freaked out—some servers won't even come upstairs to use the employee bathroom. It doesn't usually bother me because I figure no one is here to hurt me, but last night something happened that freaked me out. I was closing, and I went downstairs to turn off the lights in the ladies' room. I walked in and it was like I was physically stopped. You know how if you run into a wall you physically bounce back? That's what it was like. In one split second I was going in to turn off the lights, and it was like I hit a wall and bounced back. I felt a presence, and every hair on my body stood up. I just knew—somebody's here. It really freaked me out and the feeling stayed with me for awhile last night. I couldn't shake it off.

Last but not least, I came here on a Monday to pick something up. We're not open on Monday and when I was leaving I saw all the empty salt and pepper shakers, so I decided to fill them up. I was standing about six feet away from the kitchen door, and for some reason I looked over and somebody walked by the kitchen door. It sounds really cliché but it was just a white figure. Which to me sounds stupid—someone with a sheet over them like a ghost! But that's what it was, and clear as day a person walked by the kitchen door.

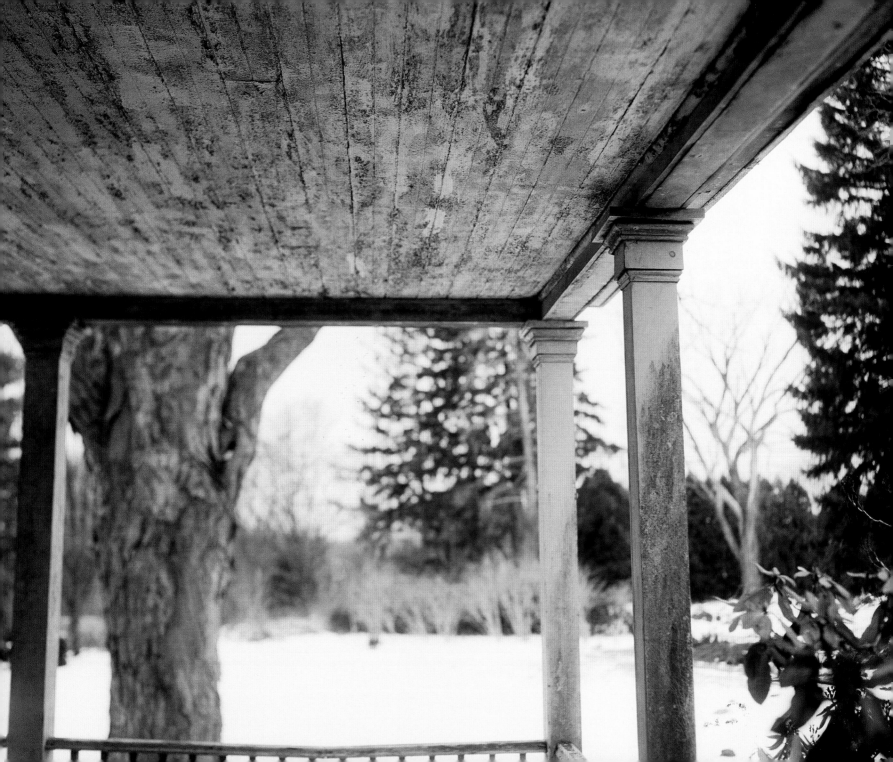

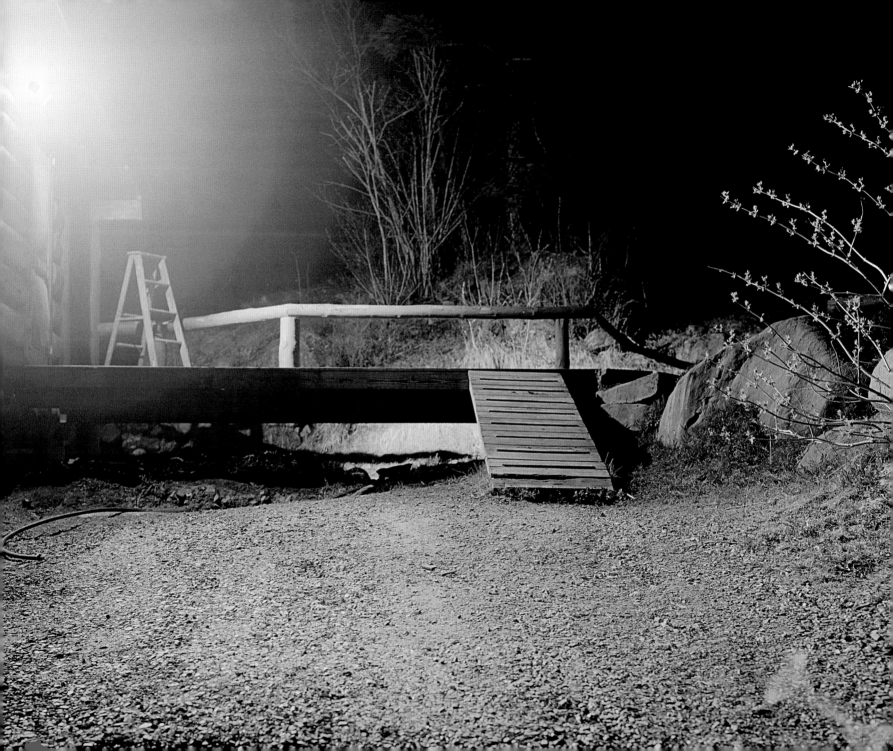

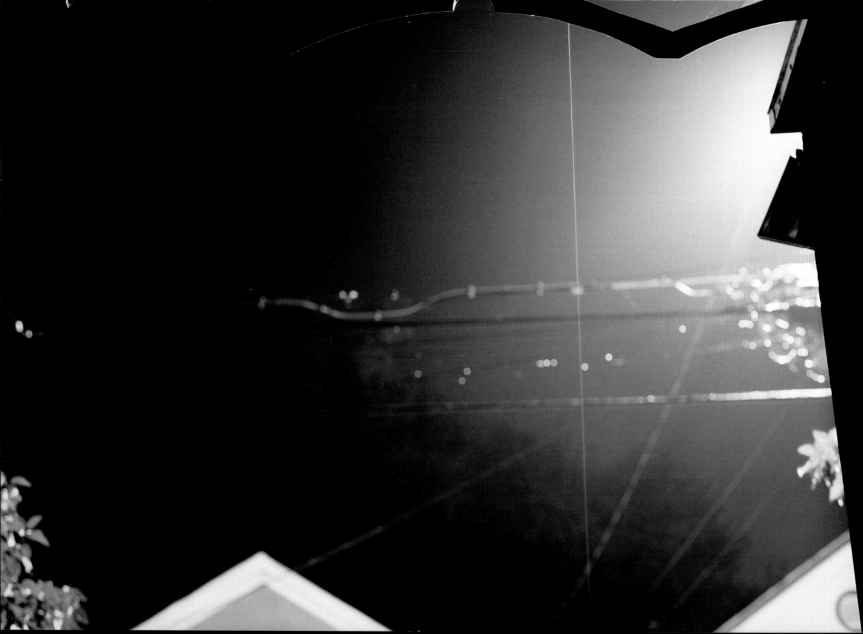

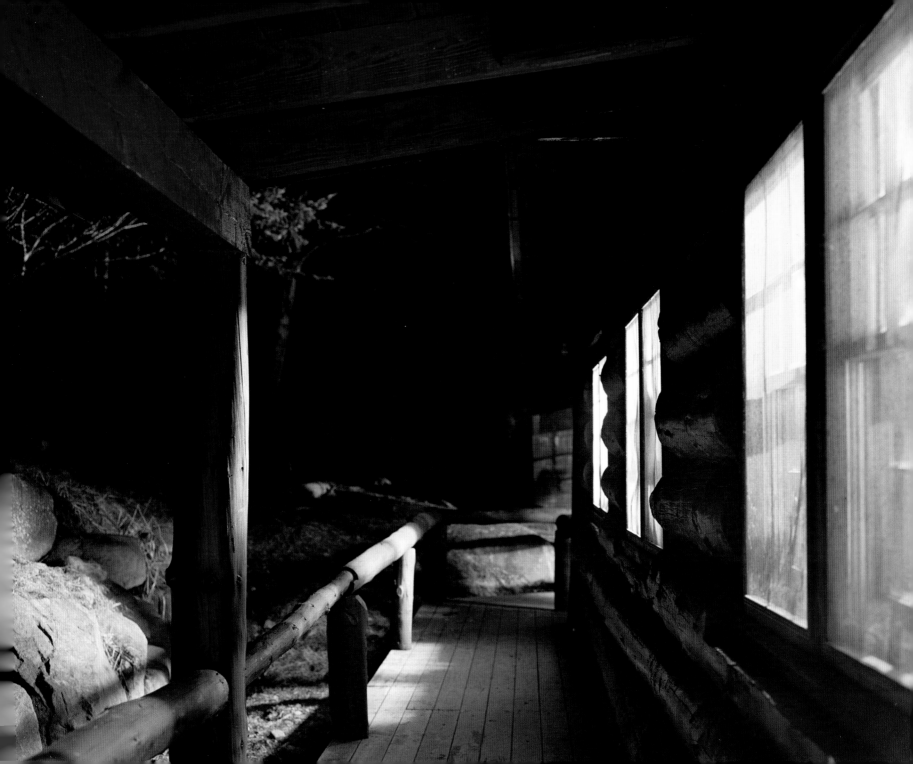

BIBLIOGRAPHY

Bachelard, Gaston. *The Poetics of Space*, trans. Maria Jolas. Boston: Beacon Press, 1994, Orig. pub. 1958.

Barthes, Roland. *Camera Lucida: Reflections on Photography*, trans. Richard Howard. New York: Farrar, Straus and Giroux, 1981.

Carpenter, Lynette and K. Wendy Kolmar, ed. *Haunting the House of Fiction: Feminist Perspectives on Ghost Stories by American Women.* Knoxville: The University of Tennessee Press, 1991.

Dalby, Richard, ed. *Victorian Ghost Stories by Eminent Women Writers*. New York: Carroll & Graf, 1989.

Dickinson, Emily. *Collected Poems of Emily Dickinson*. Orig. ed. by Mabel Loomis Todd and T. W. Higginson. New York: Avenel Books, 1982.

Fatsis, Stefan. "Is That a Haunted House You're Buying?" *The Wall Street Journal*. October 27, 1995, p. B16.

Perec, Georges. *Species of Space and Other Pieces*, ed. and trans. John Sturrock. London: Penguin Books, 1997.

Vidler, Anthony. *The Architectural Uncanny: Essays in the Modern Unhomely*. Cambridge, Mass.: The MIT Press, 1992.

ACKNOWLEDGMENTS

Thanks to all of the individuals who graciously allowed me to photograph in their homes and shared their stories. I am also grateful to the museums and historic sites that permitted me to photograph.

Special thanks to Karen Lehrman Bloch, editorial director of Grafia Books, for doing a wonderful job editing this book; Michael Worthington for his stunning book design; Elizabeth White and Andrea Monfried at The Monacelli Press; Matthew Martin; David McCormick and Leslie Falk at McCormick & Williams.

I am indebted to the many friends and family members who helped in innumerous ways, such as joining me on my travels, looking over photographs and text, providing advice and enthusiasm: Caitlin Parker, Addie Juell, Daniel D'Oca, Eric Gottesman, Joseph Maida, Joshua Green, Steven Brown, Richard Brown, Margot Demmons, Peggy Heise, Gail and Dennis D'Oca, the Saylor family, Pam and Arnie White, Chris Curreri, Dominique Rey, Naomi Fisher, Jack Wilgus, John Oser, Thibaut de Ruyter, Jessica Dickinson, Frank Benson, Julie Pate, and Rosie Shipley. Athena Torri and Jenna Salvagin for their dedication and hard work. I am particularly grateful to Jane Shipley, Britta Nielsen and Beth Griffin for their generous help with the text. Thanks to the residencies that provided me with support and time to focus on my work: Lower Manhattan Cultural Council, Skowhegan School of Painting and Sculpture, and Akademie Schloss Solitude.

I am grateful for my supportive and loving family: Betty Ryen, Mary, Jim, Leslie, Brittany, and Meghan Botz. Finally, I thank Nate Green for his love, advice, and patience, and for making our home happy.